RIVER
CHERWELL

JEAN STONE

AMBERLEY

First published 2014

Amberley Publishing
The Hill, Stroud, Gloucestershire, GL5 4EP
www.amberley-books.com

ISBN 978 1 4456 3443 2 (print)
ISBN 978 1 4456 3450 0 (ebook)

British Library Cataloguing in Publication Data.
A catalogue record for this book is available from the
British Library.

Typesetting by Amberley Publishing.
Printed in Great Britain.

Contents

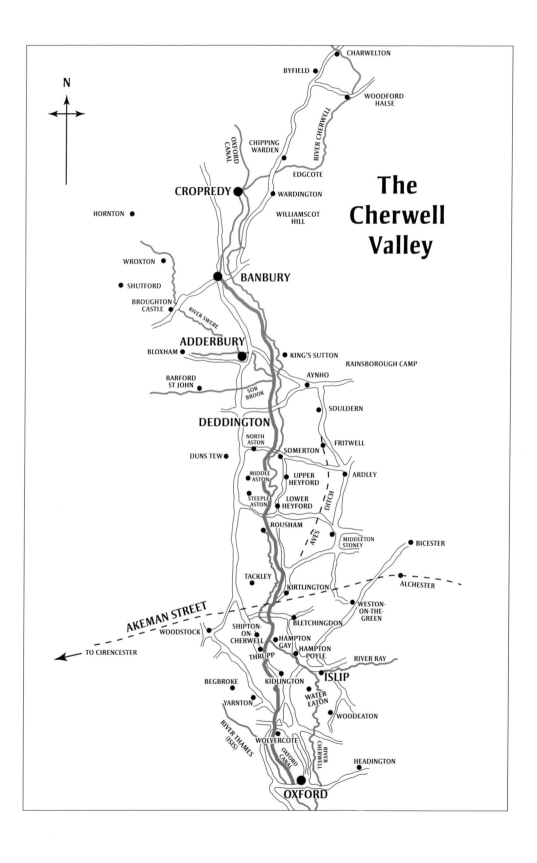

Introduction

The River Cherwell (also pronounced 'Char-well') carves its way through a broad, deep valley that runs from north to south, starting a few miles above the market town of Banbury and continuing down as far as the university city of Oxford, bending and twisting, sometimes meeting up with the Oxford Canal and parting company again as it reaches the city outskirts. It is joined by Sor Brook and the River Swere from the west near Adderbury, and by the River Ray from the east at Islip. After flowing through college meadows, it then becomes a major tributary of the River Thames, having travelled some 40 miles altogether.

The Cherwell Valley has witnessed plenty of activity since people first started to settle along its length. During this time, it has managed to retain its traditional habitats of floodplain, pastures and meadows. In the north, the valley contains red-brown marlstone, rendering soil fertile and easily worked. In the south lies the great oolite limestone, which is eminently suitable for sheep and arable crops. For centuries, these belts of ironstone and limestone have been quarried for domestic and commercial buildings, and their warm honey colour is typical for an area lying on the eastern fringe of the Cotswolds.

The Oxfordshire Cotswolds climb to over 600 feet westwards from the river, and much of the central part of the county is given over to parkland. Villages in proximity to the Cherwell Valley have expanded since the Middle Ages and, on their borders, a number of fine country houses still exist that were commissioned and landscaped to take advantage of views or amenities that this part of Oxfordshire, together with a small corner of Northamptonshire, can provide.

Since the earliest records, the River Cherwell has been used not only for its waters – to irrigate crops and turn mill wheels for grinding corn – but also for providing areas for trapping eels, a particular medieval delicacy. The Romans passed this way, followed by Saxons, Vikings and Normans. During the seventeenth-century Civil War, there is plenty of evidence to show that both Cavaliers and Roundheads were encamped along its shores at different times. In the 1700s, a canal system linking Oxford to Coventry was built. In the 1800s, the Great Western Railway was engineered to run alongside, and by the twentieth century, the M40 from London northwards was finally completed.

The following chapters will take you on a journey, following the Cherwell Valley to Oxford, tracing its history and showing how river, canal, rail and road have changed the face of the surrounding countryside and influenced development of towns and villages along the way.

Acknowledgements

I am hugely indebted to Peter and Jenny Bell for taking so much interest in this project: Peter for his technical expertise, and Jenny for assiduously correcting my grammar and spelling mistakes and being enormously helpful with general encouragement.

My grateful thanks also go to several others who have lent their support and helpful advice, and for permitting me to reproduce a selection of their images: John Amor, Henry Brougham and Bilham Woods of Kidlington & District History Society; Nicholas Allen; Elaine Arthurs, Swindon Steam Museum; John and Janet Coley; Peter Chivers, Esther Cameron and Joan Brasnett of OCC Museums Resource Centre; Steven Dance; Gillian S. Dredge of BGS; Julian Dowse; Ted and Joan Flaxman; J. Forster, archivist to His Grace the Duke of Marlborough; John Harding; Vanadia Humphries; Brian Little; Angela and David Martin-Sperry; Gareth Monger; Dr M. Peagram; Andrew Peake; Philip Powell; Lord and Lady Saye and Sele; Rose Skinner; Ian Staples and Sue; Simon Townsend, Banbury Museum; Nick Young, Newbury & Thatcham Historical Society.

PART I

Invaders

Romans, Vikings and Normans

Julius Caesar made two unsuccessful attempts to invade Britain in the years 55 and 54 BC. Nearly 100 years later, in AD 43, Emperor Claudius was successful in instigating the first proper invasion. Accordingly, having landed in present-day Kent and meeting stiff resistance from the native British, they eventually gained control over the southern third of the country.

Once fighting ceased, the Romans set about building their great hill forts and creating cities. Many villas were built west and south-east of Cherwell boundaries, and the remains of one can still be seen today at North Leigh near Witney, built on foundations of an earlier Iron Age settlement.

Trade was important and although the country already had good trading relations with Europe, the Romans obviously wished to extend these and wool was one of the main commodities that they exploited. Sheep have always flourished in parts of the Cherwell Valley, and Banbury, in the north of Oxfordshire, was soon to find its prosperity in the wool trade.

All along the Cherwell Valley, many artifacts have been recovered during various exploratory digs dating back not only to Bronze and Iron Ages but also to when the Romans travelled this way and left behind a trail of burial sites, pottery kilns and coins. In AD 58, Emperor Nero had appointed a Roman soldier, Gaius Suetonius Paulinus, to be Governor of Britain and, at this time, territory south of a line between the Wash and the Severn Estuary was settled under Roman domination.

Boudicca (born c. AD 20 and often referred to as Boadicea the Warrior Queen), together with her husband Prasutagus, ruled over the Iceni, a British tribe living in an area encompassing modern Norfolk and Suffolk.

After Prasutagus died, Boudicca was no longer protected under his influence, which resulted in complete subjugation of the Iceni. Her territory was pillaged, she was flogged and her two daughters raped. Naturally filled with fury and indignation, she fomented a rebellion with neighbouring Trinobantes, who also were eager for revenge.

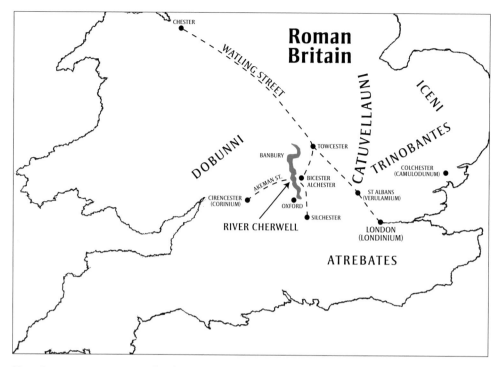

How Roman Britannia was divided.

Colchester (*Camulodunum*) had been capital of Roman Britannia for several years. It was poorly defended – awaiting reinforcements that never arrived – when Boudicca saw her chance. After a two-day siege, the town was destroyed by fire. London (*Londinium*) came next. It too was burnt to the ground and its inhabitants massacred. Boudicca, then in full control, directed her armies up Watling Street to St Albans (*Verulamium*) where, in similar fashion, the town was razed to the ground.

Meanwhile, from his base in Chester, Paulinus hurried towards Alchester where he could review the situation. Alchester today is no more than a tranquil grassy field just north of Wendlebury, measuring about 25 acres, but soon after the Romans invaded, the site was developed as a strategic position for further advances across the country. Alchester and Bicester, separated by 2 miles, were located between the Catuvellauni tribe to the east and the Dobunni tribe west of the Cherwell Valley. Paulinus then fell back along Watling Street for what turned out to be Boudicca's last battle.

The British fought bravely with arrows but Roman cavalry grouped themselves into a standard wedge formation, attacking with pikes. The British fled but most of their cattle were slaughtered and as many as 80,000 British may have been put to the sword – the Romans themselves losing only about 400 men. Boudicca and her daughters somehow escaped in the battle. She died soon after, perhaps from wounds received, but some say that she poisoned herself in order to avoid capture. Rumour has it that her body still lies under Platform 8 at London's King's Cross station. Her statue, however, raised in her memory, can be seen near the Houses of Parliament on Westminster Bridge.

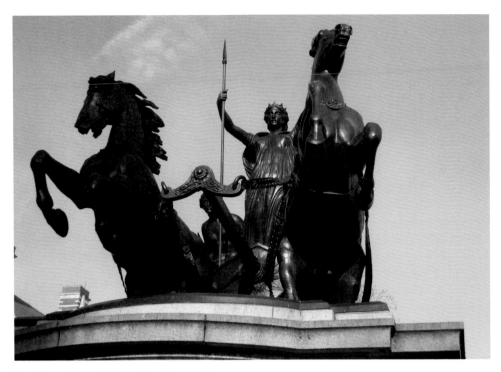

Boudicca in her chariot driven by two horses.

Roman control of the country was now established and continued for nearly 300 years, with war breaking out simultaneously along the whole of the frontier from Britannia to Egypt. The gradual Roman withdrawal in AD 410 left the country vulnerable to raids by adventurers from across the North Sea.

The first Germanic mercenaries to arrive brought their families and a new language, which was to form the basis for our subsequent English as Latin declined. Ultimately, English evolved not only from ancient Greek and Latin but also from Celtic, Anglo-Saxon, Viking, and even French. Brothers Hengist and Horsa are traditionally recognised as having led armies that slowly colonised the country. Roman Britainnia was replaced by Anglo-Saxon Britain for the next 600 years, and the country divided into four kingdoms: Northumbria, Mercia, East Anglia and Wessex – the Cherwell Valley becoming part of Mercia.

These were still pagan times, but Christianity was soon to reach our shores. According to the historian Bede, St Birinus (*c.* AD 600–649), having just been created bishop in Italy, made the long journey with express instructions to convert pagans in Wessex. In the environs of Oxford there are plenty of sites and remains of religious houses that were inaugurated several centuries later, such as St Frideswide's Priory and Osney Abbey.

The first of the Viking raids is recorded as having taken place in AD 793. They were coastal farmers constantly seeking better agricultural opportunities in lands less mountainous than their own. They had built up a strong fleet of ships that could reach

these islands speedily and be capable of making a quick getaway back to their own countries. Another reason for their wishing to invade our shores was their interest in our coinage. The Anglo-Saxons had steadily increased the use of silver coins for their purchases, but this was a new commodity for Scandinavians. At first they would fight their way ashore, taking anything they wanted by force but later, many of these raiders settled down and took up farming and trading, mostly in the north of the country.

Domesday Book and Beyond

The Norman Invasion began on 28 September 1066. Following its success in Sussex, William, Duke of Normandy, was crowned William I in London on Christmas Day, 1066.

Domesday Book, compiled in 1086, must surely be one of the most remarkable historical documents in existence. Its purpose was to examine the entire country to find out where people lived, how they lived, how much land they held and if it was rightfully theirs. It enabled commissioners not only to fix taxes for King William, but gave them powers to settle disputes. Similar to a modern-day census, it also provided information about how the population was dispersed, giving an insight into daily lives of its citizens. In Oxfordshire, the King headed a list of fifty-nine landowners, a mixture of nobility and commoners.

Mills for grinding corn along the River Cherwell were recorded in the Domesday Book for the first time. Their owners were taxed each year in shillings and rent was often paid in eels as well. They were reckoned by 'stitches', calculated at twenty-five eels to the 'stitch'. These snake-like creatures were an important item on medieval dinner tables, particularly during fasting in Lent. Traps were cone-shaped baskets made out of willow withies and baited with a dead fish. They were strategically placed where currents of water would sweep eels through a funnel, trapping them inside the basket while allowing water to flow out again. Eels could be processed in many different ways: they could be eaten fresh, salted or smoked; their fatty flesh could be blended into a variety of pies, pastes and jellies; or they could be roasted on a grill or wrapped in dough and fried.

For the next six centuries, Britain settled down under the Normans, paying their taxes and grumbling too no doubt. New landowners set about consolidating their estates, fortifying their houses in case of trouble, but at the same providing employment for local folk. Kings came and went, castles, churches and monasteries were either built or restored. Attempts were made to improve agriculture; the rearing of sheep and pigs was encouraged and markets were set up for buying and selling farmers' goods.

But during the Civil War (1642–51), the Cherwell Valley was once more invaded by troops. This time the participants were English on both sides and both used this thoroughfare on their way to or from battlefields. Soldiers and their families came, setting up their bivouacs and keeping the campfires burning well into the night. The river gave them water for their horses and their cooking pots, and on still nights voices of men singing bawdy songs could be heard by villagers in their houses on the hillsides. Towards dawn, soldiers snatched some sleep before being roused to pick up their arms and follow the flag to the next encounter.

PART II

Waterways, Railways, Highways and Byways

River Cherwell and the Oxford Canal

Among ironstone hills that rise west of Daventry in Northamptonshire, a trickle of water on their southern side betrays the birthplace of the River Cherwell. A natural watershed on Halidon Hill is responsible for several of these small beginnings. At its start, the infant river tumbles for about 10 miles through Northamptonshire before passing into Oxfordshire for the remainder of its journey. At Charwelton, it spills under a tiny, stone packhorse bridge that now forms part of the pavement along the main road, bypassing the village. The river then weaves its way through and between the Northamptonshire villages of Woodford Halse, Chipping Warden and Edgcote until it emerges into North Oxfordshire at Hay's Bridge. A few miles above Cropredy it has its first encounter with the Oxford Canal, and it is from this juncture that they will criss-cross each other, travelling south to Oxford until the river ultimately merges with the Thames (or Isis) near the city centre.

In the late 1700s, canal building was flourishing in many parts of the country. When the Duke of Bridgewater's canal was opened in 1761 to carry his coals to Manchester from his coal mines at Worsley, the price of coal dropped dramatically and many industrialists recognised the potential. It was this that prompted building the Oxford Canal. The Duke's chief engineer was James Brindley (1716–72), and he was engaged to draw up plans for this new construction. The canal would provide an important link between coalfields and factories in the Midlands through to Oxford, thereby giving access to the River Thames and thence to London.

It took more than twenty years to complete (mainly due to various disagreements as well as insufficient funds) and had to be authorised by an Act of Parliament. There was conflict as well concerning Newcastle-on-Tyne collieries. Traditionally, their coal was shipped down the East Coast to London docks and then by Thames barge to Oxford. It was resolved by introducing a clause into the Bill to prohibit coal to be conveyed from the canal into the Thames at Oxford. After wharfs at Wolvercote, the final wharf was at Hythe Bridge Street. Beyond this coal had to be transported by horse and cart.

On the fringes of the Cherwell Valley, owners of several large houses found that the projected canal was going to impinge on their properties and, accordingly, arrangements were made to allow them to build wharfs on their land should they wish to do so. At the same time, it was becoming fashionable to have their parklands landscaped. Notable among designers was William Kent, later followed by Lancelot 'Capability' Brown.

Before any work on the canal could commence, legislation had to be passed to protect the rights of these landowners and to provide suitable compensation. When the Oxford Canal Navigation Company was set up, the main shareholders were members of the nobility, such as the Duke of Marlborough of Blenheim Palace and Sir James Dashwood of Kirtlington Park. Some Oxford University colleges also bought shares, as did one or two clergymen of independent means.

Creating shares was also important to raise money in order to pay contractors in charge of each canal section, skilled and unskilled workers, equipment necessary to dig out channels, and to construct gates and sluices. Tolls and rates for the carriage of goods had to be fixed, bridges and tunnels designed and cartographers employed to draw up maps of areas involved. Great excitement was shown when construction started on the Oxford Canal, and it became a popular activity for a day's outing to watch work in progress. It was built in stages as a winding contour canal (a method used to save the costly building of locks).

James Brindley, who by all accounts was a workaholic and by this point was apparently suffering from exhaustion, did not live long enough to see it finished. His brother-in-law, Samuel Simcock, took over the project and finally saw it completed at Oxford on 1 January 1790. The section running through the Cherwell Valley measures approximately 18 miles, with fourteen locks along its length.

For fifteen years after it opened, the Oxford Canal was one of the most important and profitable transport links in Britain. It mostly carried coal from Warwickshire, but also building materials such as sand, ballast, stone, cement, and various agricultural products. For a few years, a fly-boat service was introduced for passengers and light freight, which proved an exciting way to travel for local people. Boats operated six days a week, day and night, with a crew of four working in shifts and drawn by horses, and had priority over other slower-moving craft. It was, however, a short-lived enterprise, as it was uneconomical to run and damaging to canal banks, which were eaten away by the wash from boats. Finally, in 1805, the Grand Union Canal opened, which had the effect of providing a new short route from London to Birmingham, thus taking custom away from the Oxford Canal. Brindley's creation soon became out of date with its extravagant, albeit picturesque, winding route.

Originally, working boats had an all-male crew who lived on the bank at night. Later on, boatmen started to arrange sufficient accommodation so that their wives and children could live on board, and also provide valuable day-to-day assistance. They worked long hours and raised their families in incredibly cramped conditions. How these boatwomen coped with small toddlers inevitably toppling into the water, doing the washing, the cooking and shopping was quite remarkable. Many a tale can still be heard about life on 'the Cut' (as they called it) from descendants of these folk who

have settled in close proximity to various canal systems. Their stories have been passed down by word of mouth and, simultaneously, their artistic skills have been manifested by their decorative paintings and distinctive 'Roses and Castles' artwork.

Canal trade began to decline in the mid-1800s. It had enjoyed the briefest of heydays, despite the fact that some canals were still being built by early 1850s, but they were eclipsed by the coming of the railways. At first railway companies were only interested in passenger traffic and carriage of light goods, which did not really trouble canal boats. But later, factories expected to be connected directly to a railway that was not affected by weather conditions or delays due to bridge or lock repairs. It is also interesting to note that, in 1860, there were at least 7,500 miles of railway lines in existence against 4,000 miles of canals. It is therefore not difficult to see what pressures the canals came under.

Bridges along the Oxford Canal were originally numbered, but some of these have since been lost or a bridge itself demolished. Although most bridges were built of brick or iron, two were made of stone. Nell Bridge near Aynho is one – it also happens to be the oldest – and the other is further south at Northbrook. In order to reduce costs, all the small lift bridges that frequently cross over the canal were built of wood and mainly used by farmers moving their stock from fields lying on either side.

The main canals continued to be in operation during the Second World War, but there was virtually no maintenance carried out and many smaller ones became impassable. Lock gates and bridges fell into disrepair and the British Waterways Board was eventually formed in 1948. Many volunteers came forward to take part in restorations over the following decades. The Oxford Canal was one of the very last to change from horsepower to diesel engines and, since the mid-1960s, has become one of the most popular waterways for pleasure boating and walking.

In 1997, the towpath for the Oxford Canal Walk was extended to incorporate all 85 miles from Oxford to the outskirts of Coventry.

The Great Western Railway

The Stockton & Darlington Railway line, completed in 1825, caused a worldwide sensation and, in Bristol, merchants were eagerly awaiting an opportunity to be better connected to London. In 1833, they chose a young man called Isambard Kingdom Brunel to plan a railway. He also designed a terminus to be situated in the then country suburb of Paddington. In 1841, the line to Bristol was completed and the Great Western Railway (or GWR), with its chocolate and cream livery, came into being.

An extension line was soon made to Oxford and Royal Assent was granted in August 1845 for a plan to continue the GWR from Oxford to Rugby and, consequently, the Oxford & Rugby Railway Company was set up. There were many stipulations and instructions, such as protection for the canal system, procedures for crossing roads and building and maintaining bridges. Plans for station platforms and buildings had to be formulated and tolls and fares decided upon. Official time then was either 'London' or 'Local', with Oxford officially being five minutes and two seconds behind Greenwich.

Two years later, a decision was taken to synchronise all station clocks so that trains ran to a strict timetable. One curious directive concerning some passengers read, 'Officers etc; of Oxford University to have access to stations but on no account permitted to halt the train in any place where there is not a proper station ... Fine £5.' However, Oxford colleges were encouraged to appoint special constables during the building of the railway to manage and control the workmen.

It is difficult nowadays to understand how much opposition there was from many landowners, not only in Oxfordshire, who complained that the air would be polluted, particularly in tunnels. There were worries about accidents and that views from the properties would be ruined. Compensation in some cases ran into many thousands of pounds, and some projects were never realised. The extension to Rugby was affected and, after many meetings and discussions, delays due to a multitude of differences of opinion and lack of funds resulted in it never being completed. The line eventually went instead via Banbury to Birmingham.

These pioneer trains were composed of crude, coach-like vehicles for first- and second-class passengers, while unfortunate third-class citizens had to content themselves with an open truck and a few cross planks for seats. But even with a certain amount of discomfort, it must have been hugely exciting for people to cover as much ground in a few hours as it would have previously taken them a whole day. For townsfolk, a day out in the country was possible for the first time, as it was for country folk to be able to spend a day shopping in a town or city. In 1884, an Act of Parliament decreed that even third-class passengers were to have a covered carriage and be conveyed at a minimum average speed of 12 miles an hour.

At the outset, equipment that private firms built and general rolling stock they supplied for the GWR was fairly basic. By mid-century, improvements in design and comfort began. In 1873, steam heating of compartments was introduced and, in 1874, a 46-foot coach with eight wheels appeared. Around that year, the lighting of trains by dim, evil-smelling oil lamps was replaced by gas compressed in cylinders and burners of a simple type. By the end of the century, however, trains began to be fitted with electric light.

A new era of hotels on wheels, transcontinental expresses and wagons-lits had dawned, and it seemed that the railways were here to stay. During the First World War, more than 100 independent railway companies were brought under government control and then, in 1923, they were formed into four companies with appropriate maps showing their routes and names, which were recognised until nationalisation in 1948: GWR for the West; LNER for the North East; LMS for the Midlands; and SR for the South.

An ambitious dream of Sir Edward Watkin (1819–1901) was to link northern industrial cities to capitals of Europe via a tunnel under the English Channel, but his project failed due to financial and political problems. Sir Edward's plan also involved building a new railway station at Marylebone to carry the recently formed Great Central line from London through to Nottingham, with the route passing through some areas of Oxfordshire, Northamptonshire and Warwickshire. The station was opened on 9 March 1899, and on 15 March the first express steamed out. But it was doomed to failure some years later as it never became a commercial success.

In 1838, the railway line from London to Birmingham was completed by the GWR. Later, the GWR agreed to loan sufficient money to enable the Great Central to build a new track 8½ miles long, connecting its own main line at Woodford Halse with the GWR's Oxford–Birmingham line at Banbury. Local people at Woodford Halse were greatly surprised when they suddenly found that they were to be on a major trunk route.

Marshalling yards and repair shops were built on an extended embankment north of the station with provision for the infant River Cherwell to flow through a culvert underneath. The whole project was authorised in 1896 and completed in 1900, after which it continued to handle a great deal of traffic until the 1950s. Very little remains to be seen today, except for twin bridges over Station Road. The GWR direct route to Birmingham was from a junction at Ashendon to Aynho, where it joined the company's old route to Birmingham via Oxford.

More and more people were now using railways, mostly for work but for holidays as well. The stations were spread out along the Cherwell Valley and all had plenty of customers travelling daily to Oxford, Banbury or as far as London, if their work took them there. Some schoolchildren also used trains if there were no school buses available. For journeys further afield, there were easy connections to other parts of the country.

With the onset of the Second World War, railways were busy taking evacuees from London out to places in the countryside, and Oxfordshire had its fair share of these. Later, after the period known as the 'phoney war', railways were used to return children back again to their city homes. At the same time, troops were being transported around the country with all their panoply of war and, after Britain's defeat at Dunkirk, trainloads of wounded soldiers passed through Lower Heyford station on their way to hospital. The trains also brought airmen and crew, posted to the new airfield at Upper Heyford. During the build-up of supplies for D-Day landings, the Cherwell Valley line was stretched to its limits, and many extra freight and military trains were commissioned.

But by the time they were nationalised in 1948, railways were in a substantially worn-down condition, as little maintenance or investment was carried out during the war. By the early 1950s, economic recovery and the end of fuel rationing meant increased competition as more people could afford cars and road haulage could compete for freight. The government attempt to streamline railways, thereby hoping to make them more profitable, was put into the hands of Dr Richard Beeching.

Dr Beeching's report is chiefly remembered for recommending wholesale closure of what he considered little-used and unprofitable railway lines, removal of stopping passenger trains and closure of local stations on other lines that remained open. Along the Cherwell Valley, several stations such as Cropredy and Aynho were closed and singling work was carried out, thereby reducing the line to a single platform. Maintaining punctuality and reliability is difficult when trains have to wait for a passing train to clear a single-line section. However, in the early part of the twenty-first century, with increased traffic, some of these lines have been redoubled by Cotswold Line and Chiltern Railways.

Road Transport and the M40

Before the Roman occupation, there were no roads as such. Cattle and sheep made their own tracks across fields and hills, which were often adapted in later years for transport. People either rode horses, used horses and carts or walked along these tracks when they had reason to travel from one place to another. Many of these tracks have survived in the Cherwell Valley, which has a complex of footpaths and bridleways. When the Romans arrived, they set about building roads mainly to assist their invasion and carry their troops throughout the land, but after they left, the excellent system they had built gradually fell into disrepair.

When these roads began to deteriorate, overland commercial transport naturally became increasingly difficult. Use of rivers was also a problem because of flooding, and differing levels caused rapids that had to be negotiated. On many rivers, mills were already operating in large numbers and owners were understandably reluctant to allow passage of barges that would interrupt the flow of water necessary for driving their machinery.

During these early times, most people living in villages had little ambition to travel outside their own area. In medieval times, should they wish to go visiting, alehouses provided accommodation consisting of no more than bedding on the floor of the kitchen or in a barn. Some of the earliest inns were built by monasteries in places of pilgrimage. Later, wealthier classes with country estates would travel from their town houses and, if necessary, lodge overnight at houses belonging to friends or relations. But travel then was a hazardous occupation, with brigands and robbers lying in wait for the unwary, and many a legend has grown up about these.

At the same time, road surfaces were being enhanced largely due to revenue received from turnpikes that were set up at various intervals throughout the country. Both Banbury and Oxford were important route centres, and the road running between them at that time via Woodstock was turnpiked under an act of 1755. Previously, parishes were responsible for the upkeep of roads in their parish but now people bought shares in road building, which helped with improvements. Toll houses, which were erected at appropriate places alongside roads, had six sides and two windows facing both ways so that keepers could easily spot traffic coming, extract a fee and open the gates accordingly. Not much remains of an old toll booth west of the River Cherwell on the Woodstock road close to Yarnton, and a public house called The Turnpike now occupies its space.

There are several coaching inns dotted along the Cherwell Valley, some of them originating from the sixteenth century. Among them are Reindeer Inn and Whately Hall in Banbury, Cartwright Hotel in Aynho, Red Lion in Adderbury and Holt Hotel at Steeple Aston. In many towns, still preserved today, are distinctive inns with high archways for stagecoaches and horses to pass underneath. Passengers were able to obtain refreshments, and appropriate accommodation was available for them to stay overnight.

The arrival of railways a century later was instrumental in giving people even more freedom, not only to be able to transport their goods competitively, but also to travel

to different areas of the country, which in turn gave rise to the growth of the travel industry. But with the 1900s came another change of transport. Roads began to take on a more important role after development of the motor-lorry, especially in the Midlands and South. The lorry was a deathblow to the canal system arising from the success of railways and, by the 1920s, regular long-distance heavy haulage became firmly established by road.

In Oxfordshire, more and more people were relying on their cars for travelling to work, school and leisure. Soon main trunk roads were filled to capacity and the first of the new motorways was taking shape. In 1959, the first road to be built to motorway standard was Preston Bypass, later to become part of the M6. Britain's first full-length motorway was the M1, and its first section was opened in November that same year.

The M40 was built in stages between the 1960s and 1990s. Originally it ran from London to Oxford, terminating at Junction 8, the turn-off for Thame and Aylesbury. This section was completed in 1974. The section from here through the Cherwell Valley to join with the M42 south of Birmingham – known as the 'missing link' – was only completed between 1988 and 1990. Afterwards, reduction of traffic for many towns and villages along the valley was quite dramatic. Practically overnight, lorries and other commercial vehicles (many of them coming from Europe heading for all places north) were no longer pounding through the high streets of so many of the county's villages. One obstacle to be overcome, however, was caused by some vigorous complaints concerned with preserving wildlife at Otmoor Nature Reserve, south of Oxford. It was eventually decided to add a sweeping bend of several miles to avoid this area, thus delaying completion of the M40, which finally opened in 1990.

PART III

People and Places

Charwelton to Cropredy

From its source near the village of Charwelton (from which its name is taken), the River Cherwell meanders for about 10 miles through and around several Northamptonshire villages before reaching Oxfordshire. It passes first between the villages of Hinton and Woodford Halse. Possibly this area was at the forefront of Sir Edward Watkin's thoughts when he dreamed of building the Great Central Railway from London

The infant river flows under Charwelton Bridge.

through to the North of England. The main line for this doomed project opened here in 1899, creating a whole new industry until it fell under Dr Beeching's axe in 1966. Chipping Warden can boast some extensively damaged remains of an Iron Age hill fort, as well as the remains of a Roman villa on the banks of the still infant River Cherwell. Edgcote House was built of local ironstone in the eighteenth century and the park, laid out at the same time, features a lake formed by the river. Somewhere between here and Lower Wardington is the site of a famous Wars of the Roses battle – the Battle of Edgcote in 1469 – but the exact location has yet to be determined.

Over the border in Oxfordshire, the River Cherwell slips under Hay's Bridge a mile or so north of Wardington. South of the village is Williamscot Hill, referred to as Kalabergo's Hill after a murder that took place there in the nineteenth century. Giovanni Maria Kalabergo was an Italian jeweller and watchmaker and had been living and trading in Banbury for some forty years when his nephew came to stay. Guglielmo Giovanni Kalabergo had arrived to lodge and work with the family just a couple of months before his uncle went missing. The nephew was arrested and the whole story came out in detail during the trial, which was reported at length in local newspapers and is still remembered in Banbury to this day.

Evidently, Guglielmo was in some kind of trouble at home in Italy and he was sent to his uncle in England for some discipline. He resented this and plotted how to get rid of Mr Kalabergo in order to inherit his wealth. He stole money from the shop till to purchase a pistol and his opportunity came one day when they were visiting villages together by horse and trap. On 10 January 1852, Guglielmo shot and killed his uncle and threw the pistol into a ditch. He then ran home saying some robbers had attacked them and wounded the old man. That same evening, passing strangers came across a horse standing quietly by the trap near the road, which is on a direct route from Williamscot to Banbury. Further on they found Mr Kalabergo's body lying in the snow in a pool of blood. After being tried for murder that March at the Lent Assizes, Guglielmo was found guilty, sentenced to death and hanged at Oxford Castle a few weeks later.

One of the more notable villages that the river reaches first in Oxfordshire is Cropredy. The village of Cropredy has its roots in Anglo-Saxon times and is mentioned in Domesday Book as having three mills at 35s 4d. The river skirts the east side of the village and passes under Cropredy Bridge, where an important Civil War battle took place at the end of June 1644.

This was the valley's first encounter with the battles that occurred within the Cherwell Valley area, though campaigns took place in many different locations throughout the country during the years 1642–50. The main contention was that Charles I was determined to raise taxes without approval from Parliament and, after much slaughter, loss of life and destruction of property, the King surrendered and was later beheaded in the Tower of London.

During the battle for Cropredy Bridge, Prince Rupert of the Rhine (1619–82), his brother Maurice (1620–52) and Thomas Wentworth, 1st Earl of Cleveland (1591–1667), were the main combatants for the Royalists. Prince Rupert's mother, Elizabeth, was sister to Charles I and married to Frederick V, Elector Palatine and

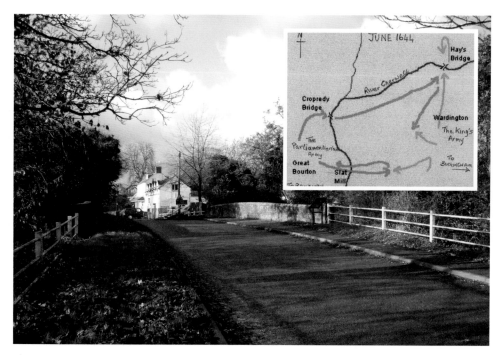

The map inset reads:

JUNE 1644
N
Hay's Bridge
River Cherwell
Cropredy Bridge
Wardington
The King's Army
The Parliamentarian Army
Great Bourton
Slat Mill
To Buckingham

Cropredy Bridge from Hay's Bridge. Inset: The Battle of Cropredy Bridge.

a strong supporter of the Holy Roman Empire. The family had to flee to Holland because of political problems and Prince Rupert and his siblings were brought up in The Hague. Both brothers came to England in support of their uncle and, when not engaged in battles, spent some happy days hunting in Woodstock Park. Thomas Wentworth, by all accounts, was an extravagant personality and an expert cavalryman, but he was captured twice during the Civil War and was a prisoner in the Tower until 1656. His cavalry charge to capture guns on Cropredy Bridge was considered to be the most brilliant incident of all the battles.

For Parliament were Robert Devereux, 3rd Earl of Essex (1591–1646), and Sir William Waller (c. 1598–1668). Robert Devereux was a controversial character, had two failed marriages and was not popular with some because of the views he expressed. He was the first to complain that his failures in battle were due to sickness and desertions amongst his soldiers. Sir William Waller was born into an influential Kentish family and was educated at Magdalen College, Oxford, after which he became a Member of Parliament before joining the Army. He was a strict Presbyterian and had a certain number of disagreements with Lord Essex, until they came together at Cropredy. After the war, he gave up his military career and entered Parliament again. His sympathies now lay with the Royalists, which caused him to change sides and become involved in negotiations for the return of Charles II. He then retired to his country estates.

Here then in Cropredy, on a quiet morning on 29 June 1644, the two opposing armies were on either side of the river – at one time, almost without realising it, they

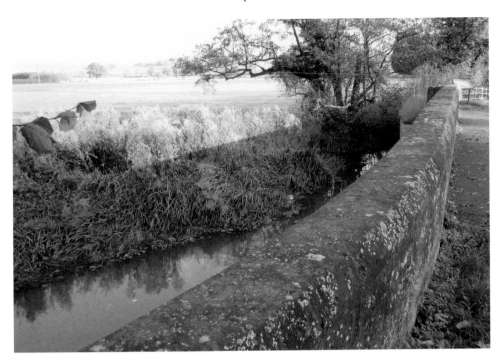

Looking back towards Hay's Bridge.

were positioned just a mile apart. The Parliamentarians marched from the west towards Banbury. They arrived at a good vantage point on Bourton Hill overlooking Cropredy and sent a sufficient force with artillery to seize the village's bridge.

The Royalists, coming from Buckingham, were also marching towards Banbury from Edgcote on the east side, but deployed some of their troops to secure Hay's Bridge. At the head of the Royalist rearguard, the Earl of Cleveland drew up his cavalry on rising ground facing Cropredy Bridge and led a counter-attack. Several cavalry charges and skirmishes took place during that day and, by evening, Cromwell's forces had suffered many casualties. Although all their guns had been captured, they succeeded in preventing the King's forces from crossing the bridge.

On the bridge is a plaque recording this event that reads, 'Site of the Battle of Cropredy Bridge. From Civil War deliver us.' The Sealed Knot Society (named after the original 'Sealed Knot' whose aim was the restoration of the monarchy) have visited the village and succeeded in attracting large crowds to watch their realistic and authentic re-enactment.

The parish church of St Mary's, constructed in local ironstone, was mostly rebuilt in the fourteenth century and contains some artifacts from the 1644 battle. One of its greatest treasures is a pre-Reformation brass lectern in the shape of an eagle standing on three chunky lions. A hole in the eagle's beak is thought to be for Peter's Pence (retrievable via its tail), which was a voluntary payment made to Rome – the practice no doubt ceased after the Reformation. Parishioners were quick to dump their valuable lectern in the river during the Civil War and it was later recovered and restored to its rightful place.

From Bourton Hill, guns were seen on Cropredy Bridge.

In 1790, the Oxford Canal opened here and, at one time, there was a coal wharf, a corn granary and some brickworks. Behind the Red Lion public house are stables where the horses that hauled the narrowboats were fed, watered and rested overnight. In the 1850s, a railway station was constructed by the GWR, but British Railways closed it down in 1956.

A short distance north of Cropredy Lock is Broadmoor Bridge and Lock. It is here that, more than twenty-five years ago, local residents Ian Staples and his partner Sue arrived with their two typically decorated narrowboats. They were fortunate enough to acquire a portion of land alongside the canal and proceeded to make it their home. In his spare time, Ian is a musician and landscape painter. Sue, having retired from being a trained occupational therapist, is a textile artist who practices from home. All along the canal there are many instances of people living and working and enjoying a different kind of lifestyle to those who choose to settle in towns or villages.

Across the canal from Broadmoor Bridge, a bridle road leads to the hamlet of Prescote, which lies between the River Cherwell and Highfurlong Brook.

Prescote is associated with the legend of St Fremund, who some concede was the son of King Offa of Mercia. Fremund had won a battle to prove he was his father's heir and, as he knelt in a prayer of thanksgiving, one of his own men, jealous of his success, beheaded him. The tale goes on to relate that a wolfhound guarded the head until Fremund's followers arrived. The corpse then rose to its feet, picked up its head and walked away. When it stopped a little later, a miraculous well sprung up and after Fremund had carefully washed his head, he lay down and died. Cropredy received

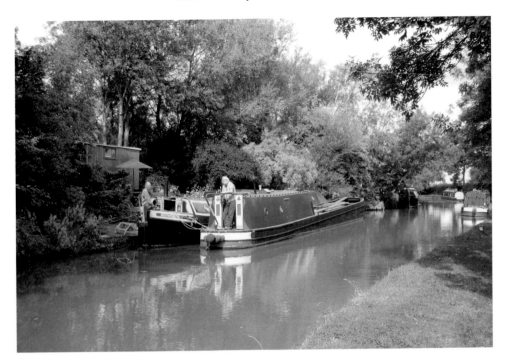

Canal dwellers on their narrowboats.

his remains in around AD 931 before they were taken to a new shrine in Dunstable. The Cropredy shrine apparently continued to be venerated until destroyed during the Reformation.

The manor house at Prescote was later the home of Walter Gostelow (only his baptism is recorded in 1604), who famously preached fire-and-brimstone-type sermons. He evidently considered himself capable of having visionary powers as he once suggested possible brides for Charles II. On another occasion, he foresaw himself and his family rising up to heaven in a mixed company of Stuarts and Oliver Cromwell.

As the River Cherwell progresses south, it passes what was the first major watermill along its course at Slat Mill Bridge. This site, which also had a significant role to play during the Battle of Cropredy Bridge, is where the second of Cropredy's famous events takes place. Since 1976, these fields have witnessed an annual festival in August, when a three-day folk and rock concert run by Fairport Convention is held.

From here, the Oxford Canal and the River Cherwell proceed to journey in tandem southwards to Banbury. The canal continues straight on through the town centre while the river glides slightly eastwards and makes its way via the middle of what was once an old Saxon settlement at Grimsbury before squeezing past the main line railway station.

South of this point, the railway closely follows the Cherwell Valley, leaving the river to skirt the aptly named Cherwell Street and flow out again into the countryside, where it winds and weaves along the valley floor as it descends to its final destination at Oxford.

Banbury

The market town of Banbury is possibly best known for its nursery rhyme:

> Ride a cock-horse to Banbury Cross;
> To see a fine lady upon a white horse.

Since April 2002, decorated floral horse heads on sticks, echoing the legendary poem, have been placed around the Banbury Cross annually to celebrate the new Hobby Horse Festival. In April 2005, the long-awaited statue of the Lady on the White Horse was erected to one side of the cross and was unveiled by HRH the Princess Royal. The 'lady' herself is traditionally believed to have been a member of the Fiennes (pronounced 'fines') family from Broughton Castle, who frequently rode around a large part of the country on her trusty steed in the seventeenth century. This may not be strictly accurate as there have been quite a few contenders for 'the fine lady' title, including Queen Elizabeth I, Lady Godiva and Lady Katherine Banbury.

In medieval times there were three crosses in different parts of the town, but a zealous mob of Puritans destroyed them all in 1602. The present cross was erected in the nineteenth century to celebrate the marriage of Princess Victoria, the eldest child of Queen Victoria, and Prince Frederick William of Prussia in 1858. It is not necessarily in the same location as the original ones. The location of the site and composition of the cross was discussed with the townspeople of Banbury for many years, and it was not completed until 1914.

Broughton Castle lies about 2 miles south-west of Banbury, where Sor Brook and its three tributaries combine to create a natural site for a moated manor. In 1898, the historian Sir Charles Oman described it as being 'about the most beautiful castle in all England … for sheer loveliness of the combination of water, woods and picturesque buildings'. The house was built in 1300 for Sir John de Broughton and was sold to William of Wykeham, Bishop of Winchester, in 1377. In 1451, the Fiennes family inherited the castle and, except for a short period during the Civil War, successive members of the family have lived there ever since.

Avowed Puritan William Fiennes, the 1st Viscount and 8th Baron Saye and Sele, and his four sons actively supported the Parliamentarians and raised troops from men working on his estate to fight against the King. In September 1642, Oxford was being made safe for King Charles' expected arrival but this was foiled by Lord Saye arriving with a posse of soldiers and taking charge. Curiously, after a few weeks he left the town pretty much unguarded and proceeded northwards, possibly sensing that a vital battle might be in the offing. In October, after the Battle of Edgehill, Royalist troops led by Prince Rupert besieged not only Banbury Castle but Broughton Castle as well, and occupied it for a time. In the Oak Room over the fireplace is a large seascape by Johannes Peeters depicting Charles II sailing for England off the coast of Holland in 1660. A little later, the 1st Viscount tactfully placed an inscription in Latin over the doorway that reads '*Quod olim fuit, meminisse minime iuvat*' ('There is no pleasure in the memory of the past'). Today, the present Lord and Lady Saye and Sele still reside

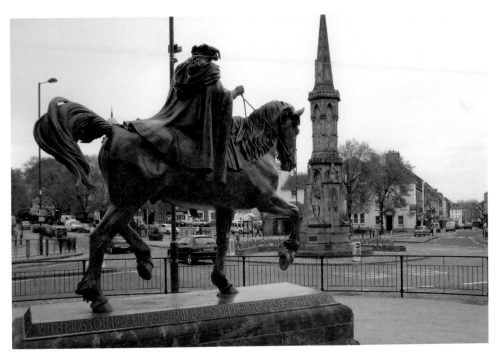

A Fine Lady riding towards Banbury Cross.

there. Their castle and gardens are frequently open to the public and many events are held there every year.

There is evidence of a Roman villa at Wykham Park between Broughton and Bloxham, but it was the Saxons who built the first settlement of Banbury west of the river, and then a second one at Grimsbury on the opposite bank. 'Banna's burgh' was the original name, derived from a chieftain who built his stockade there in the sixth century. In 1135, Alexander, Bishop of Lincoln, who owned the village of Banesberie (its Domesday name), built a castle, made land available for houses and started a market. The village soon became a town and, during the fourteenth and fifteenth centuries, as trade grew, there was a cattle market in Broad Lane, a sheep market at the east end of the High Street and a bread market. In 1586, the first mention was made of Banbury Cakes, a type of pastry mixed with currants, which is still a favourite today. Since the seventeenth century, a general market has been held each Thursday and there is now also one on Saturdays, with a monthly farmers' market on a Friday.

There have been any number of fairs since medieval times. It was one way of signifying the seasons, such as Christmas and Easter, and at the time of harvest or seed sowing. Many festivals were based on pagan rites and then adapted for Christian use, and they were highly popular in the days before television and mass media. One festival not so well known as some is Lammas Eve, which is held on the night of 31 July. This ancient feast marked the change from summer to autumn and the beginning of the harvest season in medieval times. Lammas, which can be translated as 'loaf mass', was a celebration where loaves of bread were baked from the very first harvest of grains.

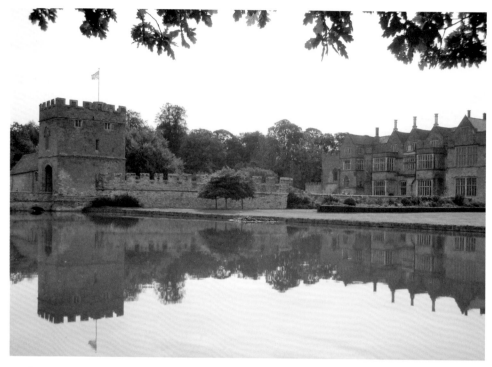

Looking across the lake to Broughton Castle.

Cromwell is believed to have plotted at the Reindeer Inn.

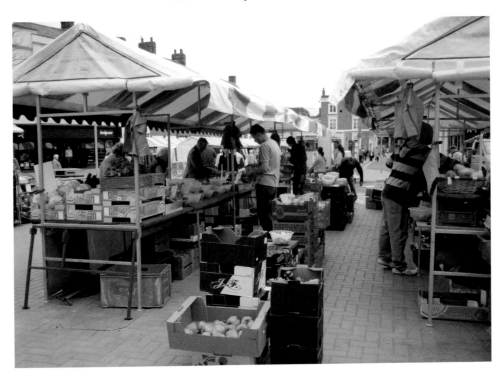

Market day in Banbury.

Banbury was famous for the many fairs that were held in the town. They included leather fairs, horse fairs, cow fairs, fish fairs, cheese fairs and wool fairs (wool was one of the town's main industries, along with leather). Nowadays, each October crowds gather as the traditional Michaelmas Fair comes to town. In the same month, the popular mop or hiring fair used to be held. During this fair, labourers would wait anxiously on the streets while the farmers chose who would be employed for the coming year.

In 1642, soon after the Civil War began, Royalist soldiers occupying Banbury Castle were besieged twice by the Parliamentarians and finally surrendered to them in May 1646. It is said that Oliver Cromwell planned the Battle of Edgehill in a back room of the Reindeer Inn in Parsons Street, which was also used as a law court on occasions. In 1648, despite it having been extended and rebuilt many times, the castle was demolished and the stone given to the townspeople for their use. It had occupied an area west of where the canal is now located. In the twentieth century, a substantial watermill on the river nearby was converted into a theatre and arts centre. A new sports and recreation centre was later constructed on the east bank of the river.

After the depredations suffered by the townspeople of Banbury during the two devastating Civil War sieges, it took a while for them to salvage what they could and restore their dwellings. Gradually, their old trades returned, markets flourished again and the manufacture of new types of cloth also helped recovery. By the turn of the century, a horse girth and blanket industry was established and soon a new fine-quality

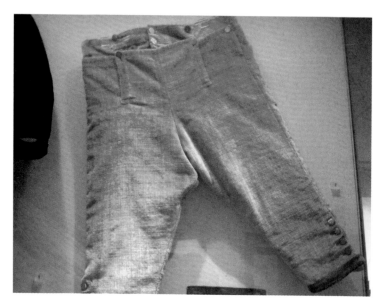

Plush trousers for a servant's livery.

fabric evolved, known at first as shag and then as plush. Together, these textiles were to be Banbury's main products for the next hundred years.

Plush, made from fine worsted wool, silk, cotton or mohair, was woven to produce a shaggy finish similar to velvet. In the 1700s, it was used mainly for clothing, then later for curtains, tablecloths, upholstery and smaller decorative items. Servants' livery plush was exported from Banbury to embassies, noble households and courts in Europe, Iran, China and Africa.

Banbury was the centre of plush making but much of the weaving was done in surrounding villages such as Shutford, Bloxham, Bodicote, Chacombe and Drayton. Early handloom weavers and their families worked at home and by 1841, there were 170 working weavers, with plush masters supplying the raw materials, collecting the finished pieces and paying the families.

The village of Shutford saw the beginning and end of plush weaving in the area. In 1747, Thomas Wrench, the first of a family of plush masters, founded a firm there which continued to make plush until 1848. This village had the highest concentration of weavers after Banbury itself. When Cubitt & Co. closed in Banbury in 1909, Wrench & Co. acquired their equipment and moved it to Shutford, thus becoming the last makers of handwoven livery plush in the world. In 1913, the workshops and their contents were destroyed in a fire, though the firm recovered and continued to make plush in the village. The industry finally closed in the 1940s due to decreasing demand.

In the nineteenth century, Banbury's industrial expansion occurred, as did most towns in the country following the Industrial Revolution. Engineering works sprung up, brickmaking facilities were in full production and a hop garden south of the town supplied the local brewing trade. There has always been a certain amount of light industry both east and north of the town. Today, if the wind is blowing in the right direction, a passer-by can catch a strong smell of coffee, which is more than likely

emanating from a large factory owned by Kraft. Banbury thus became an important manufacturing centre as well as a market town. Engineering took over from cloth making as the town's main industry. Samuelson's Britannia Ironworks was established in 1849 and specialised in agricultural machinery – its most famous product was the Banbury turnip cutter, currently on display in the Banbury Museum. In Victorian times, turnips were fed to sheep and cattle during winter months. These had to be topped and chopped by hand, not an enviable task for farm workers, so a machine that saved their hands in cold and icy weather was a much-appreciated invention.

Raw materials of coke, sand and iron arrived by canal and were distributed to the many factories springing up around Banbury. From the 1850s, manufactured goods left by rail, exported to the rest of Britain and overseas. All this activity caused an influx of new people and the town sprawled well beyond its medieval limits. Terraces of workers' houses were built near the river and canal in the Cherwell area and west of the town in Neithrop.

By 1778, the Oxford Canal had reached Banbury, bringing a cheap and reliable supply of Warwickshire coal. A modern shopping centre has grown up around the route of the canal where Tooley's Boatyard is situated. Tooley's is the oldest working dry dock on the British inland waterways network and has been in continuous use for over 200 years. It was established in 1790 to build and repair wooden horse-drawn narrowboats. As canal trade dwindled due to increased rail and road transport, its future was in jeopardy. It was also threatened when Castle Quay was developed in the 1990s. Eventually, it was realised that it was a site of some importance and it was duly listed as an ancient monument and became part of Banbury's museum and heritage centre. All the old workshops have been completely restored so that visitors can watch craftsmen plying their trades. Boat trips and tours can be organised, and it is even possible to learn traditional techniques by taking a blacksmith course.

Much revered by local boating people was Tom Rolt. Before the Second World War, he was concerned at the plight of the canal systems, but also realised that there was potential for their restoration. In 1939, he and his first wife Angela set off from Tooley's Boatyard – where his narrowboat *Cressy* was moored – to see for himself how dilapidated the canals had become. Afterwards, he wrote a best-selling book called *Narrow Boat*, describing the 'forlorn and abandoned' waterways along which he had travelled.

In 1946, the Inland Waterways Association was set up and Tom Rolt joined as one of its founding members. Since then, much has been done to restore the weed-choked, disused waterways, to rebuild locks and generally increase the recreational value of canals, not only for boating people but also for walkers, anglers and wildlife enthusiasts.

In 1850, Banbury's railway line first arrived, and now, after several amendments (including those made by Dr Beeching), the station has two main services along the Cherwell Valley from London: First Great Western from Paddington and Chiltern Railways from Marylebone.

The Banbury cattle market, which covered an area of 17 acres in the Grimsbury district, was well-known as the largest of its kind in Europe, with many animals arriving on the hoof. In later years, local residents started to despair at the state of their

Tooley's boatyard.

roads every time animals passed their way to and from market. No one really wanted it to go but after attempts to move it to a new site were thwarted, it finally shut down in June 1998. Thus ended 800 years of livestock trading in the town.

King's Sutton

After leaving Banbury, the River Cherwell and the Oxford Canal are still in tandem as they travel south. They pass Twyford Wharf, once an important trading point on the canal, and reach King's Sutton, whose railway station is the first stop between Banbury and Oxford.

> King's Sutton is a pretty town
> And lies all in a Valley;
> There is a pretty ring of bells
> Besides a bowling alley;
> Wine and liquor in good store,
> Pretty maidens plenty;
> Can a man desire more?
> There ain't such a town in twenty!

Thus goes the old nursery rhyme published by Halliwell in 1760.

King's Sutton, first mentioned in the Domesday Book as 'Sudtone', lies at the very southern tip of Northamptonshire. Perhaps this was why, in Saxon times, 'sutton' was a word meaning 'south farm'. Since the village belonged to the King, 'Kinges Sutton'

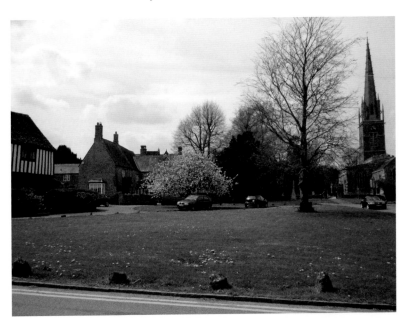

The village
green at King's
Sutton.

became an accepted spelling. It lies in a valley and is a very picture-postcard village
with its thatched cottages, manor house and medieval church arranged around its
village green. The church of St Peter and St Paul has, according to Pevsner in *The
Buildings of Northamptonshire* (1961), 'one of the finest, if not the finest, spire in this
county of spires'. He reckoned it to date from the late fourteenth century and gave its
height as 198 feet. A publication by Thomas North in 1878 entitled *The Church Bells
of Northamptonshire* sets out a tradition of bell-ringing that was adopted by many
churches at that time. One extract states:

> A Morning-bell is rung at 5am from Lady Mass to Michaelmas. A bell is rung daily at
> noon and curfew at 8pm. At death-knell, three tolls are given for a male and two for
> a female. The bells are chimed both before and after a Funeral. On Sundays, the bells
> are chimed for Divine Service.

A few miles east of here, near the village of Charlton, is Rainsborough Camp, the site
of an Iron Age settlement dating from sixth century BC. Covering an area of around
6½ acres, it lies on the edge of a plateau with a gentle north-west slope giving a wide
view across the Cherwell Valley. It is roughly circular in shape and lies in a hollow,
which is unusual as hill forts were normally built on a high mound for defence purposes.
At some stage, it was stormed and burnt down, resulting in the roof timbers falling in.
In the eighteenth century, a local farmer who was restoring part of his stone-walling,
removed various ancient tree stumps and edged the area with chestnut trees. It is likely
that ploughing was carried out at the site, but for now it remains as pasture land.

In the seventeenth century, the people in King's Sutton had Royalist tendencies
during the Civil War and harboured the King for a time. After the first major battle of

the Civil War, which took place on Sunday 23 October 1642 at Edge Hill, King Charles is believed to have been hidden in the manor house while Royalist soldiers were defending river crossings at both Twyford and Nell bridges. The King later withdrew to Oxford, which he used as his base until his capture and trial in London.

In 1690, Celia Fiennes (of 'fine lady' fame) rode over from Broughton Castle to King's Sutton in order to sample the waters from a spring that had recently emerged by the roadside at nearby Astrop. It caused quite a stir for the local people and they called in a couple of physicians to test it. After careful deliberation, they agreed that it was pure and possibly contained medicinal properties. Dr Radcliffe, who later had a hospital named after him in Oxford, came over from Steeple Aston (where he was rector) to take the waters and many others followed suit. It soon gained notoriety and people would undertake the long journey from London just to sample these waters as they had heard they had cured many a complaint.

Astrop House, with its grounds designed by Lancelot 'Capability' Brown, became a centre for highly fashionable house parties, and attracted the aristocracy who flocked down from London. One of the rich and famous personages to stay was the author Horace Walpole.

In time, the spring's popularity began to decline when society preferred to visit the larger spas and pump rooms that were being built at Leamington, Bath and Tunbridge Wells. The Astrop waters, which sometimes caused a few unpleasant side effects, have long since been deemed unsuitable for human consumption. The spring is still visible on the outskirts of the village beside the road towards Brackley. It is marked by an ornate stone structure, which has a strange legend connected with it. St Rumbold's Well was named after a baby who was born in the seventh century and who lived for only one day. During this short time it is said that he was baptised in

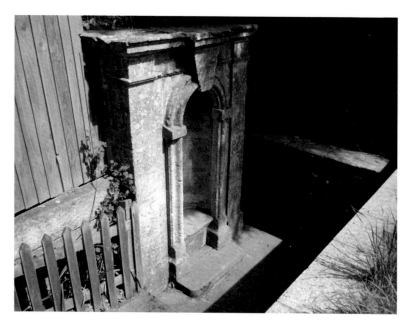

Rumbold's Well on the way to Astrop.

a huge concave stone of prodigious weight, received Holy Communion and then preached a sermon. Curiously, in 1923, some workmen repairing a fallen pinnacle from the church spire were asked by the incumbent vicar to remove a large mound of earth nearby. In so doing, a huge and extremely heavy concave stone was revealed. It was adopted as the church font and recorded by Pevsner as 'rough, plain Norman ... the lead lined bowl measures 2ft.8ins internally'. Although he describes the interior of the church at length, he makes no mention of St Rumbold's Well. He does, however, point out some stocks that are still preserved between the manor house and the Bell Inn, as well as the sixteenth-century half stone and half timber-framed courthouse with its first-floor great chamber. Another story of this intriguing village concerns the Great Fire that broke out on 13 July 1785 at the house of a Mr Collingbridge. A washerwoman was blamed for instigating the disaster as she had carelessly left a fire she had just lit to search for more fuel. Forty-four houses were destroyed and, unsurprisingly, fire insurance was promptly instigated. A carved stone recording the date of the fire used to be located at the old Cooper's Stores in Astrop Street.

By 1790, the stretch of canal passing King's Sutton had been completed. William Willes (who had married Sophia Cartwright of Aynho in 1826 and lived at the manor), owning much of the land through which the new railway line was to pass, finally received compensation. By 1850, sixty years after the canal came into operation, all station buildings and platforms were erected, and track for the GWR was laid on this section of the line from Oxford.

Adderbury with Bloxham

Directly west from King's Sutton and straddling the A4260 is the village of Adderbury (or Eadburggebyrig in its evocative Saxon spelling). It is bounded on the east by the River Cherwell, and the village itself is divided into two. West Adderbury and East Adderbury are separated by Sor Brook, which drains into the Cherwell. Another tributary is the River Swere to the south, which divides the village from the neighbouring parish of Deddington. The ancient parish also included Bodicote, Barford St John and Milton up until the twentieth century.

There has been an airfield at Barford St John since the 1930s, and it was here that Sir Frank Whittle tried out his new invention: the turbojet engine. Local people still recall seeing an aircraft flying overhead in the 1940s, its engine making strange and deafening noises, with no idea that history was being made. In 2011, a commemorative plaque was unveiled on the airstrip in memory of Sir Frank's achievement.

Adderbury has its share of old stone cottages, many built out of the ginger-coloured marlstone that is used for so many Oxfordshire village houses. Some of these overlook a village green that for hundreds of years has traditionally been the scene of a number of festivals and fairs. The main Oxford to Banbury road divides the green from the Red Lion, an old coaching inn with a high archway leading to stables beyond. It is here that each year people turn out to watch performances by Morris dancers. No one can quite explain the origins of Morris dancing. It possibly has its roots in pagan

fertility rites where young men would stamp upon the earth hoping to make it yield a good harvest. These white-clad figures with banners, sticks and bells, attended by musicians and sometimes a fool, are a familiar sight at country shows and fêtes. The Cotswolds Morris dancers, with their own traditional steps and tunes, have certainly been around for centuries. The Red Lion is probably the oldest public house in the village and together with the Coach and Horses and The Bell, these are the only ones still surviving out of half a dozen or so.

The village boasts two manor houses: Adderbury House, which stands on the earlier site of the medieval manor and was once owned by the Bishop of Winchester; and The Grange, also with medieval foundations with a spacious tithe barn nearby. An early thirteenth-century church of St Mary has a noteworthy spire that is one of the tallest and most important in the county and can be compared with that of St Mary's at Bloxham, a few miles west of Adderbury. Possibly the same masons worked on both churches. The old saying goes: 'Adderbury for Length, Bloxham for Strength and King's Sutton for Beauty'.

The Domesday Book states 'the Bishop of Winchester holds Adderbury', and so it was that a later Bishop of Winchester became affiliated with the parish receiving income from the church. William of Wykeham (*c*. 1324–1404) was born in Hampshire in humble circumstances but swiftly rose to power and great wealth, becoming Bishop

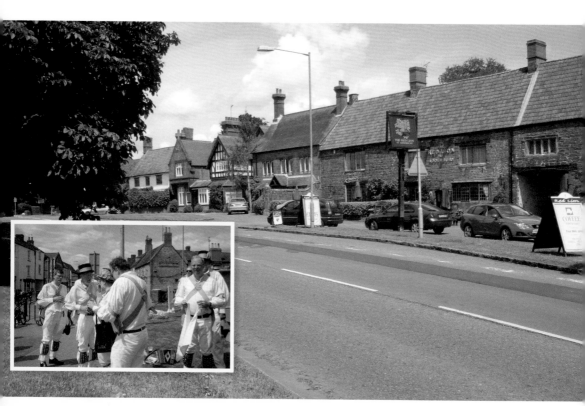

The Red Lion at Adderbury where Morris dancing (*inset*) takes place.

of Winchester and Lord High Chancellor of England in 1367. With revenue from Adderbury and from another estate in Cambridgeshire that he held, he went on to found New College in Oxford and also a college at Winchester for 'poor' pupils. After his death, his head adorned with his mitre together with his coat of arms were carved on a parapet in St Mary's (the parish church), perhaps at the same time that a massive marble tomb was erected for him in Winchester Cathedral.

Since Roman times, agriculture has flourished in Adderbury and, at Domesday, this territory was divided in two sections, east and west, with one part being cultivated and the other left fallow. There were also several mills standing along both Sor Brook and the River Swere. Some of these were used for fulling (a process whereby woollen cloth was cleansed of impurities and then rinsed with water) or for papermaking, but none have survived. By the late 1700s, the medieval practice of cultivating land in strips and allowing parishioners to graze their animals on common land was completely altered following the Parliamentary Enclosure Acts. It was a wasteful system and some changes were needed but, nevertheless, it caused a lot of dissension among farming folks.

In the seventeenth century, the Civil War at times caused confusion as to who supported whom within the county. The north of the county was strongly pro-Parliament, but not always. Equally, the south would appear to be in support of the King. But this was not always the case. Very often families were divided, as were village

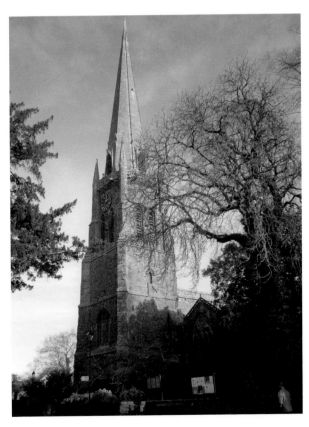

St Mary's at Bloxham, across the field from St Mary's at Adderbury.

Sor Brook at
Adderbury.

communities. Local people, although they were usually granted a small allowance, were expected to provide food and lodging for whichever side was occupying them at the time. On market days, villagers driving their sheep and geese along main roads would find themselves swept to one side as a troop of cavalry or foot soldiers charged past. Very often, if a road surface was bad or if they thought it would be quicker, soldiers would swerve across fields, trampling crops as they went, which also aided their foraging for food. They were never averse to purloining horses and carts for their purposes, and there were many complaints of damage to crops and property.

Adderbury, because of its situation in a direct line between the Royalists in Oxford and the Parliamentarians in Banbury, certainly played host to both sides' troops at different times. A few days after the Battle of Edgehill, and while the King's soldiers were defending Twyford Bridge (on the road to King's Sutton) and Nell Bridge (on the road to Aynho), the Royalist army attacked both castles of Broughton and Banbury, which fell with little opposition.

At this time, Adderbury House was owned by the Wilmot family. Henry Wilmot, a son of Charles Wilmot, 1st Viscount Wilmot of Athlone, was one of King Charles' senior cavalry commanders. He had fought with the Dutch army but joined the service of the King at the outset of the Civil War. In June 1643, he was created Baron Wilmot of Adderbury and, a few months later, was put in charge of the garrison in Banbury. In August, some skirmishing took place between Parliamentarian troops stationed at Aynho and some Royalists who, although still occupying part of Adderbury, made a swift retreat to Deddington. A month later, the Parliamentarian general, the Earl of Essex, hastened to the village, dispatched a troop of horses to Deddington and chased the Royalist soldiers back to Banbury.

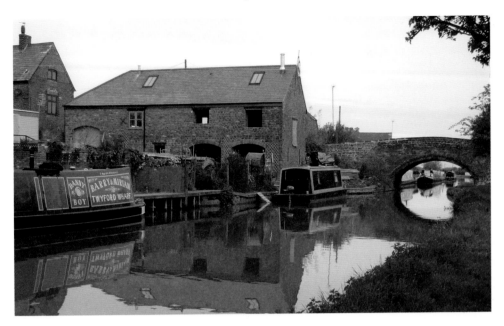

Twyford Wharf, built for the increasing canal traffic.

After the Battle of Cropredy Bridge in June 1644, Lord Wilmot was accused of trying to reach an agreement with Lord Essex. He was deprived of his command and exiled to France. After he died, his widow Anne made various additions to Adderbury House. After her death, the house changed hands several times. It was remodelled a few times and then sold for use as an old people's home in the 1940s. In the 1990s, Lake House, a purpose-built care home, was built in the grounds. Adderbury House lay derelict for some years until some renovation took place, enabling the house to return to private ownership once again.

The Oxford Canal was completed in 1790, and three wharfs were immediately set up at Twyford, Adderbury and Nell Bridge to cope with the expected volume of traffic. Cheap coal was now available from collieries in the Midlands and although there were plenty of carriers on hand plying their trade, farmers benefitted from being able to get their crops to market quicker and more efficiently. It is interesting to note that a quantity of ironstone was uncovered when the canal was being dug near Adderbury village, but it was not until some years later, in 1859, that it was considered to be a commercial proposition and eventually mined and transported by rail to smelting foundries.

Adderbury was not the only parish in the Cherwell Valley with ironstone on its doorstep. From the late 1800s until the mid-twentieth century, several quarries with varying quantities were excavated – at Charwelton and Byfield in Northamptonshire, Wroxton west of Banbury, and Nell Bridge, Astrop and Aynho in the King's Sutton area. These were areas where marlstone rock was so prolific that before mechanisation, ironstone was dug out by hand with picks and shovels in opencast mines. Special tracks were laid for locomotives to pull laden wagons to the kilns, which dried the ore, or to

take it to the plant for crushing. In some instances, steam-operated lifts then carried the wagons upwards in order to tip the ore inside. After this procedure, it was discharged into wagons once again for transit to the GWR railways and then carried away to the Midlands and South Wales for further processing. Horton stone, which comes in different shades of orange-brown, is still used for building, but most of the quarries mentioned have either been phased out or dismantled and nowadays only traces of their rusting equipment and railway tracks are visible.

The GWR's railway line came to Adderbury in 1850, a station was built in the south of the village in 1887, and the line was closed in 1951.

Sor Brook, having sliced Adderbury in two, begins at Edge Hill before passing through and between Alkerton, Balscott, Shutford and Broughton Castle. It serves as a boundary between Broughton and Bloxham, a few miles due west from Adderbury. Bloxham itself is dissected by a tributary running into Sor Brook, and at one time there were three mills operating along these streams. The village is famously known in modern times for Bloxham School and the Warriner School, but in medieval times, the triangle of Broughton, Adderbury and Bloxham were intrinsically linked.

After William of Wykeham died, his great-nephew Thomas Wykeham inherited a large fortune as well as Broughton Castle. In 1418, he bought some land in Adderbury together with the manor house at Bloxham and, some years later, his granddaughter married into the Fiennes family. The Cartwrights of Aynho also owned property here during the seventeenth century, mainly for junior members of their family, and occupied a house that was later designated for the headmaster of Bloxham School.

In 1327, the village was noted for being 'more flourishing than any other rural community in North Oxfordshire'. This was a short-lived claim to fame, however, as this view was reversed a few years later. It was an agricultural community similar to its neighbours, with a good proportion of arable crops, sheep and cattle. In 1552, Richard Fiennes was sued for letting his rabbits eat some of his tenants' corn. He was urged to breed his rabbits in a confined area by building a strong wall to contain them, which he agreed to do and added a pledge that if any escaped they could be lawfully killed.

The twelfth-century church of St Mary, built out of Hornton stone, lies at the southern end of the main street. With its notable spire it 'is one of the grandest churches in the county', according to Pevsner. Inside are carvings and mouldings, an inspiring Last Judgement on the west wall, a faded St Christopher with two companions, some twelfth-century stained glass and nineteenth-century windows designed by William Morris and Edward Burne-Jones.

During the eighteenth century, the government became increasingly aware that Britain's defences were not all they should be following invasion scares resulting from wars with France and Spain. Something also needed to be done to quell the rioting that was becoming more prevalent.

The government accordingly instructed the Lord Lieutenants of each county to raise a force comprising a certain number of able-bodied men. Although officers were drawn from the aristocracy and gentry, non-commissioned officers and troopers were recruited from farmers, tradespeople and estate workers. The term 'yeomanry' was derived from this.

In 1798, four Yeomanry troops were raised in Oxfordshire and one of the first was the Bloxham and Banbury Troop with Sir Thomas Cobb in charge. Their duties mainly entailed quelling the riots that were getting more and more out of hand during the early 1800s. As standards of living gradually improved, unrest became less frequent. Consequently, the troops changed names several times before becoming forerunners of the Queen's Own Oxfordshire Hussars, whose descendants were to gain fame in later conflicts – the Boer War and First and Second World Wars.

After the First World War, ironstone was being quarried at Bloxham and Lord Saye and Sele leased mineral rights to a steel company. After the Second World War, a carpet mill (converted to a business centre early in the twenty-first century) was established a short way south of the village making fine quality Wilton carpets, partly by hand.

Aynho with Clifton and Deddington

The canal and river are still just a few yards from each other as they reach Nell Bridge, under which the canal passes. The river itself takes a route under the main road leading to Aynho and then crosses the canal at a right angle, flowing in on the east side and out over a weir on the west side. Meanwhile, the towpath is carried over on a series of brick arches. A few yards below this crossing is Aynho Weir Lock, which is of an unusual, irregular, octagonal shape and takes the canal only about 1 foot below the river. This extra width allows sufficient water to be passed through the system.

Adjacent to Aynho Weir, the railway route splits and, south of this junction, the original line continues down the Cherwell Valley to Oxford. Along this part troughs of water were laid between the rails and fed by the river so that locomotives could scoop up water for their tanks without having to stop. East of this junction, a more direct route (opened in 1910 by the GWR) runs via Bicester and High Wycombe to London.

The Northamptonshire village of Aynho lies a mile east of Nell Bridge and is situated on a hilltop overlooking the river below. It is known locally as the 'apricot village' because, for as long as can be remembered, all cottages lining the main street were encouraged to grow apricot trees on their walls. In feudal times, it was traditionally supposed that villagers harvested apricots to pay for their rent and the choicest specimens were no doubt selected for the squire's table. Some trees still survive to this day but due to the changes from thatch to roof slates, cobbles to concrete on pavements, and the addition of gutters, many have been lost as rain could no longer reach their roots.

At the time of the Norman Conquest, Aynhoe Park (no one knows why this is spelt differently to the village) was occupied by a Saxon thane and standard-bearer to Edward the Confessor. He was ousted by the invaders and had to cede his property to Geoffre (or Geoffrey) de Mandeville, 1st Earl of Essex, whose family continued to live there for several generations. Later, various families were in residence until Richard Cartwright, a Cheshire barrister whose wife Mary (née Egerton) had just presented him with a son and heir, purchased the property from playwright Shakerley Marmion in 1615.

When Richard died, his son John inherited the estate. Despite having Royalist connections through marriage, John was in fact a fanatical Parliamentarian. It was noticeable that when King Charles stayed at Aynhoe, John was nowhere to be seen. Royalist troops were stationed for a time at the house, which boasted an excellent defensive position with views across the Cherwell River valley below, almost to Edge Hill. In 1645, after being defeated at the Battle of Naseby, troops retreating to Oxford burnt down much of the house. Repairs were undertaken and, in the 1700s, Thomas Cartwright started reconstructions that are very much visible today.

In 1792, William Ralph Cartwright, having been on the Grand Tour in Europe, brought home some grandiose ideas for the house and employed Sir John Soane to carry out alterations, with the final changes taking place a few years later. During the Second World War, the house was occupied by Army personnel and the park used not only for their vehicles but also as a depot for storing petrol. After hostilities ceased, it took the family several years to restore their home to its former glory and, in 1950, it was one of the first country houses in the area to be opened to the public.

The Cartwright family remained there for over 300 years in a direct male line until a devastating accident occurred on the night of 31 March 1954. Richard Fairfax William Cartwright was driving his only son, eighteen-year-old Edward, home from Eton when they crashed into an unlit lorry parked on a corner in the dark. Both of them were killed instantly and because of crippling double death duties, the estate had to be sold. The new owners, Country Houses Association, converted the house into thirty apartments but allowed the principle rooms to remain unaltered. These rooms and the grounds could be visited as ownership of the park, another of 'Capability' Brown's creations, was retained by the association. In 2003, the association went into liquidation and, the following year, the house was bought by a private owner, James Perkins, who remodelled the premises to comply with regulations, so it is now available to hire for weddings and parties.

In the fourteenth-century St Michael's church are memorials to the Cartwright family, many of whom are buried there. The Cartwright Hotel on the other side of the road bears the arms of the Chigi (a powerful Italian family from Siena) to whom the mother of the last squire belonged. In 1654, John Cartwright converted a Tudor yeoman's house east of the inn into a free grammar school. This later became the dower house for Aynhoe Park until 1967, following the death of Lady Mary Cartwright. North of the Grammar House, the almshouses built in 1822 still exist, as do the stocks, which are behind locked gates at the junction of the road leading to Clifton.

In the 1850s, the village was served by two railway stations constructed by the GWR. Aynho station was closed in 1964, but its building is still intact today. The second station, Aynho Park Halt, a short distance east of Aynho station, was also closed around that time and its building also remains intact. Nearby on the Oxford Canal are Aynho Wharf and a public house, Great Western Arms, which now belongs to Hook Norton Brewery. On 1 October 1852, a dramatic incident occurred shortly before the railway line was officially opened to passengers. A special excursion train carrying the GWR directors, officers and their ladies in ten carriages drawn by a locomotive named *Lord of the Isles* (which had been recently on display at the Great Exhibition in London)

left Paddington at 9.00 a.m., bound for Oxford and due to arrive at 10.15 a.m. It was decorated all over with laurels and flags, and Brunel and his superintendent of locomotives, Daniel Gooch (later to be promoted to chairman of GWR), were on the footplate and a band of the Life Guards played stirring music en route. It is possibly because of all this panoply and excitement that it arrived an hour late and had to hurry on to its next stop.

At Aynho it passed a disused signal at 'all clear' and the main line signal at 'danger'. A local train was detaching wagons at the station when this special train approached at speed. Its braking system was not very effective and the inevitable happened. With a great squeal of wheels, the *Lord of the Isles* ploughed into the back of the goods train.

Six passengers were hurt and taken to hospital, the disabled locomotive was put in a siding and Brunel and his officials then travelled ignominiously in two carriages drawn by the local train's engine. This then returned to collect the rest of the party and took them to Leamington Spa. Originally, the train should have gone to Birmingham first to pick up more passengers and thence to Leamington Spa for a gala dinner at the Royal Hotel. The hapless passengers were provided with alternative transport, and eventually all sat down to dine together. After the banquet, during which the band undauntedly played on, there were speeches and cheers for a successful (as it turned out) venture. However, the local press was not so impressed and berated the expedition for its 'reckless behaviour' and condemned the party for their mismanagement.

Downhill from Aynho, a link road runs over both the canal and railway, crosses the valley and climbs up to the hamlet of Clifton, east of Deddington.

> Aynho on the hill
> Clifton in the clay
> Dirty drunken Deddington
> And Hempton high way

So goes the old song.

It would seem rather an insult to the good citizens of Deddington unless they happened to know the legend. The story goes that in 1634, the medieval church's west tower collapsed and the bells lay on the ground unguarded. They were still unattended when the Civil War began and local villagers were not slow in seeing their potential. Four of the five bells were sold to soldiers to be made into cannon balls, with a promise from the King that they would be restored after fighting ceased. Local clergy were not amused but publicans thought it a good joke and declared it was 'open house' for all concerned. Many days of drunken revelry followed. The road running east-west through Hempton gives fine views of rolling countryside to the north, not that these inebriated citizens would have noticed.

Bowman's Bridge is an old packhorse bridge over South Brook, a small tributary of the River Cherwell. The meadows below Clifton are very often flooded in winter, creating a haven for many varieties of wildfowl. Although the Domesday Book stated that there were three mills at 41s and 100 eels, later records disclose that there was also a paper mill in the early nineteenth century, which was subsequently converted into a corn mill.

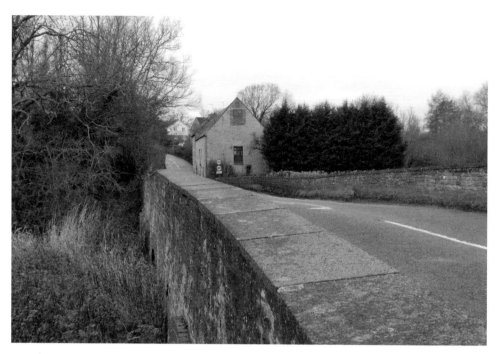

The old mill and river bridge at Clifton.

Along Clifton's main street, which is lined with old stone cottages, is an eighteenth-century public house called the Duke of Cumberland's Head. There is no real explanation for its name, but it is thought that in 1726, Prince William, the four-year-old son of King George II and Queen Caroline, was created Duke of Cumberland and possibly the inn was named after him. In the mid-nineteenth century, the then licensee ran a beaver hat factory in an adjacent building. In those days, top hats were a necessity for well-dressed gentlemen and were sometimes fashioned out of felted beaver fur.

Deddington is a few miles west of Clifton and, close to the village's eastern boundary, extensive earthworks mark the site of a motte and bailey castle. In the eleventh century, Deddington Castle, covering an area of about 8 acres, was built following the Norman invasion for Bishop Odo of Bayeux. The bishop had come over with his half-brother William the Conqueror and, with unprecedented haste, acquired a huge number of estates across the land. He had also assembled a fleet of ships for the invasion and was probably somewhere towards the rear at the Battle of Hastings. He was believed to have instigated the manufacture of the Bayeux Tapestry and his image features in one of the scenes. Deddington Castle was abandoned in the thirteenth century and is now a grassy place shaded by mature trees and administered by English Heritage.

Many of Deddington's houses and its church are built of the rusty-coloured ironstone that comes from the abundance of quarries north of the area. The twelfth-century church of St Peter and St Paul stands north-east of a roughly rectangular village green and has been extended considerably since its inception. A massive west tower

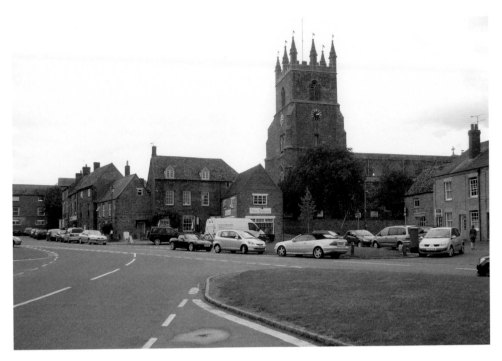

Deddington village green.

with eight pinnacles and gilded vanes was rebuilt towards the end of the seventeenth century to replace the one that had collapsed in 1634. As nothing had been done to restore the bells purloined during the Civil War, parishioners petitioned Queen Anne in 1709 for the promise made by Charles I to be fulfilled. They were told that no record could be found of this incident, so it was not until 1791 that the present ring of six bells was cast.

On the west side of the green is a red-brick town hall, which was built in 1806 to replace an earlier one. A room upstairs was mainly used for vestry meetings and also served as a courthouse. In 1994, a coat of arms was granted and is proudly displayed on its south wall. On its north wall is a classic 1925 red telephone box, designed by Sir Giles Gilbert Scott.

In the early Middle Ages, sheep played an important part in Deddington's economy. Later on, farms also grew crops and kept pigs and cattle. Control of bulls was evidently the rector's prerogative as in 1579 it was ordered that no one else might keep a bull for longer than a fortnight after the feast of St John the Baptist (24 June). In its heyday, the centre of Market Place was reserved for pigs; sheep were sold in Bullring; and horses occupied Horse Fair, where some original iron tethering rings still remain. Markets were held here frequently from at least the eleventh century, but they began to decline in the eighteenth century. Various fairs were also held over the centuries and, particularly between the eighteenth and early nineteenth centuries, the October Fair was where servants were hired, cattle sold and oxen roasted.

One famous person to have unluckily chosen to stop in Deddington was Piers Gaveston. He was a favourite of Edward II and although he had great charm, his exploits enraged many of the nobility. It was while he was being transported south for his own safety that he stopped in the village, staying overnight at Castle House (now a private home). His greatest enemy, the Earl of Warwick, learnt of his location and ambushed him. He was carried off to Blacklow Hill near Warwick Castle and beheaded there. During the Civil War, Royalist troops were often stationed in Deddington and, after the Battle of Cropredy Bridge, Charles I also stayed overnight in Castle House (without mishap) on his way back to Oxford.

Somerton

In 1066, Bishop Odo of Bayeux and Miles Crispin shared the lordship of Somerton, a village situated a few miles south of Aynho that stands on a limestone escarpment east of the river and canal. Previously, Anglo-Saxons picked this spot because of its good water supply. They found that their cattle could graze here in summer months in meadows along riverbanks rather than a drier area higher up in the village. 'Sumortun' can be translated as a farm used in summer.

Although most of Somerton's inhabitants have been farmers or labourers by tradition, many of them worked in mills. In 1086, one mill paid a rent of 20s a year and 400 eels. By the fifteenth century, there were two mills, one of which may well have been a fulling mill (where woollen cloth was treated). In the sixteenth century, three mills were recorded but by the eighteenth century only one remained.

The disused flour mill buildings, situated west of the river and at the extreme east corner of North Aston, were converted into a private house in the 1960s. The village itself lies a mile or so further west on higher ground. On low ground near the river, there is evidence of a medieval castle complete with dovecot, fishponds, curtilages and gardens. This castle was occupied by the de Grey family for many years, until the Fermor family arrived on the scene. Earlier in the thirteenth century, the village had been divided between two sisters, each inheriting half. In 1512, William Fermor was given powers to unite these two manors at a yearly rate of £15 11s. His successors then went on to feature quite prominently during the following centuries.

In the sixteenth century, as most of the castle was in ruins, they decided to build a spacious manor house on a new site south-east of the village. By 1625, Henry Fermor had moved to Tusmore near Bicester, leaving his sister (then married to Lord Arundell) in residence at Somerton.

In 1758, William Fermor visited Rome to consult architect Robert Mylne (1734–1811) with plans to build yet another house at Tusmore, using stone from a quarry at Fritwell as well as from the now deserted Somerton house. The family, however, must have felt some attachment to the village of Somerton as, from the sixteenth to eighteenth centuries, they managed to obtain possession of the whole parish of Somerton. They were then able to retain ownership of a great deal of land, including the two mills, which were let out to tenants.

By the late nineteenth century, ownership of Tusmore passed to the Earl of Effingham, who greatly extended the house. Then in 1960, the present owner, Wafic Said (a Saudi-Arabian businessman responsible for establishing the Said Business School attached to Oxford University) rebuilt the house once again.

In 1580, Thomas Fermor, concerned about the education of local children, endowed a free school in Somerton. However, it was never a great success due to various disputes that arose. Mainly, children had to be able to read and write before they were admitted and it therefore turned out only to serve children of the richest families. After Richard Fermor died in 1654, five generations were to follow until the nineteenth century, when William Fermor (1806–28) died without a male heir.

In 1765, an earlier William was instrumental in obtaining an Act of Parliament to enclose the open fields, which at that time was a common occurrence throughout much of the country. Enclosure was often not formally recorded until later, when it was shown on maps of the day.

There were many enclosure riots across the country in the early 1600s after petitions to the House of Commons were ignored. Local people were unhappy at land being changed from arable to sheep pastures, which caused their grazing rights to be taken away. After a while, the government started to change its tune and, having first targeted the rebels, became critical of those landlords whose economic behaviour had provoked the rebellions.

The river below Somerton.

For the original settlers, enclosing farms and houses was a normal way of affording protection from wild animals and raiders right up to the early eighteenth century. At that time, most other land was unfenced and regarded as 'common land' where local residents had certain grazing rights. Unhappy at the lack of controls landowners had over their own lands, the enclosure movement started around 1760 and lasted until 1820. Acts of Parliament were pursued to extinguish common rights over common land. When an Enclosure Bill was passed by Parliament and received Royal assent, commissioners were appointed to draw up plans and the landowner was instructed to enclose their land within a certain time frame. It was a long, drawn-out and cumbersome procedure. To simplify the number of Acts that were applied for as a result of this directive, the General Enclosure Acts of 1801 and 1845 were approved and land enclosure became an established practice. Not everyone was happy with these arrangements, particularly the poor people of a parish who found themselves unable to graze their cattle.

An old map of 1767 shows that most land in Somerton was devoted to pasture for cattle, but in the second half of the nineteenth century, two local farmers are recorded as being sheep breeders and just over half the cultivated land was under grass. Consequently, many arable fields were lost and there was not sufficient work to employ local labourers, which in turn caused a great deal of distress for them and their families and also led to a significant drop in population figures.

In 1815, the last William Fermor sold out to George Villiers, 5th Earl of Jersey, from Middleton Stoney. In the same year, because the free school was only for boys, Lady Jersey opened two other schools for boys and girls. By 1854, she was maintaining both schools in the village but in the nineteenth century, these two were merged with the original Fermor school.

St James church, a fine stone building originally from the twelfth century and added to later, contains several Fermor family monuments, as well as a private chapel for the family's use. In 1552, the church had three bells and a sanctus bell. Between 1635 and 1707, it is recorded that five of the ring of six bells were cast in a foundry at Chalcombe. The Fermors themselves were Catholics and, even after they moved to Tusmore, they still preferred to be buried here in what they considered to be their church. There was probably always a fairly large Catholic community in Somerton, and the Reformation passed by without too much disturbance. A medieval stone reredos in the church depicting the Last Supper (complete except for Judas) escaped damage during these times and was most likely hidden away by parishioners with Royalist sympathies.

There are several bridges that cross the river between Somerton and North Aston that were originally supposed to be maintained by both parishes. Sometimes arguments broke out, particularly over 'Gambon brugge' near the thirteenth-century mill, which is in fact just within North Aston's boundary. Eventually, in 1624, an agreement was reached so that the lord of Aston was to maintain the bridge over 'old Charwell' and the next bridge towards Somerton .The lord of Somerton was to maintain all other bridges and a causeway to Somerton.

In 1790, the canal running parallel to the river was completed together with a wharf and weighbridge, both of which are now disused. Somerton Deep Lock – measuring

12 feet deep – is one of the deepest locks on the system. The lock cottage itself is unusual in that it has no road access and can only be reached along a towpath. When the railway line was finally built close to the canal, the Earl of Jersey was persuaded to part with some of his land (bought from William Fermor in 1815) in exchange for having a convenient station provided for him. In 1855, it opened on the site of the Domesday mill and, in 1955, it was renamed Fritwell and Somerton (in order to avoid confusion with Somerton in Somerset).

Meanwhile, in 1850, GWR paid £200 compensation for the annexation of some school land. Out of this, Lady Jersey spent £75 for repairs to the school building. A link road was also created running from North Aston, past the Railway Inn (a private house since 1960) and continuing on to Ardley. The goods train service was withdrawn first in 1964, and was soon followed by the passenger service.

Ardley with Fritwell and Souldern

East of Somerton's main street, a steep hill climbs up onto a plateau that stretches for several miles towards Fewcott, its road winding between old stone houses and barns and thence to Ardley. Part of Ardley was redeveloped in the 1990s to create a junction to take the road over the busy M40 and through several roundabouts onto the A43 to Northampton. Between here and Somerton, the country road is flanked by high hedges and this is where Troy Farm is located.

Troy Farm dates from the sixteenth century and at one time may have belonged to the Aston family of Somerton. Opposite the farmhouse, through an arch in a hedge, is a path in a tree-lined tunnel leading to a circular 'troy' or maze, which can be described as a 'seven-ring classical labyrinth'. It is fashioned out of turf comprised of banks and ditches, each about a foot wide and measuring 60 feet by 50 feet. Labyrinths have their origins in Ancient Greek times, and are possibly named after the siege of Troy. Another source (mentioned by Pevsner) suggests the possibility of confusion with the island of Crete and the legendary Minotaur. The Somerton turf maze is just one of several that are still in existance in Britain, but because they are situated on private land, they are not widely advertised.

Even older than Troy Farm maze, some of the longest fossilised dinosaur tracks in Britain have been found at Ardley Quarry. Around 160 million years ago, a shallow sea covered most of Oxfordshire and it is in this mixture of limestone and mud that skeletons and fossils have been preserved. The floor of the quarry revealed that in the Middle Jurassic period, this area was a gradually shelving mudbank leading to a marshy area, and one set of footprints preserved in the limestone belonged to an 8-metre-long Megalosaurus. Footprints and a model of the dinosaur are on show at The Oxfordshire Museum in Woodstock.

Not a complete skeleton but a collection of bones from this 150 million-year-old creature is on display at the Oxford University Museum of Natural History. It is particularly interesting because, in 1824, an Oxford geologist, the Revd Dr William Buckland, created the name of Megalosaurus (translated as Giant Lizard) and

The first Megalosaurus skeleton was found near Ardley Quarry. (Courtesy of Gareth Monger)

made it the subject of the very first scientific description of a dinosaur. Outside the museum, plaster casts of its huge footprints stride away across the grass. Part of the right side of the lower jaw of this creature is also in the museum, showing that its teeth were constantly being replaced, common with other reptiles. At around the same time, footprints of an even longer creature were uncovered at Ardley Quarry – the Cetiosaurus oxoniensis (or Oxford Whale Lizard), approximately 15 metres long from head to tail.

From Ardley, a small road running north-west reaches the boundary of Fritwell, another of Bishop Odo's holdings. On the banks of the River Cherwell, a water mill was mentioned in 1235 and, by the fourteenth century, was valued at *6s 8d*. On Fritwell's highest point, Ploughly Hill, there was once a round barrow that served as a meeting place in medieval times. When it was levelled in the nineteenth century in order to grow crops, a collection of human bones was uncovered. Several roads converged on the hill in those days, including the pre-Roman Portway and Aves Ditch, which ended here from Kirtlington. In Fritwell itself, a number of well-preserved houses lie on both sides of the village, as there was much rebuilding in the eighteenth century. In 1580, Richard Fermor of Somerton inherited property here. It remained in his family, who lived in Tusmore from the mid-seventeenth century until the death of William Fermor in 1828. Afterwards, Pembroke College in Oxford owned it until the estate was broken up in the twentieth century. There is also an eleventh-century church dedicated to St Olave, a Norwegian saint, which would indicate that there was some Scandavian influence at the time it was built.

North of Ploughly Hill, the village of Souldern nestles in a hollow and abuts the southernmost boundary of Aynhoe Park. Since the eleventh century, the road between Aynho and Somerton on the east side of the village makes a convenient boundary, leaving the village in a quiet cul-de-sac. Situated at this junction with the main road, an original toll house has been converted to a private house, so too has a fourteenth-century corn mill. Many houses in the village are built from local stone of

a silvery colour with traces of yellow lichen and their roofs either slated or thatched. Of the larger houses, most were constructed around the 1660s, and the present manor house is situated on high ground sloping gently down towards the Cherwell Valley. It was a largely Catholic community but, during the Civil War, local people were imposed upon by both Parliamentarian and Royalist troops and, later on, were ordered to supply carts and provisions to the King at Oxford.

Souldern is mainly an agricultural village with arable, pasture and meadow land along the banks of the river, where free fishing rights have been available since medieval times. It has remained mainly as a grazing parish with most farmsteads let out to tenants. In the seventeenth century, a large number of trades and crafts were recorded, including eight masons, perhaps not a surprising number considering the amount of good stone in this area. Cheesemaking was another rewarding occupation, with fifteen cheesemakers working at Manor Farm. One flourishing cottage industry was lacemaking and, in 1851, there were over thirty lacemakers and several schools were set up to teach this skill.

Two sections of the old GWR railway lines – Banbury to Oxford and Birmingham to London – ran along the east side of the valley close to the River Cherwell and the Oxford Canal. A canal wharf was built, connected to the parish by Wharf Lane so that Souldern, like other villages bordering the canal, was able to enjoy cheap coal.

The Heyfords and Middleton Stoney

Just below Somerton village lies pastureland that soon changes into water meadows as the river and canal meander together towards the two small villages of Upper and Lower Heyford, a few miles apart from each other.

Both villages have certain historical similarities and are recorded as having taken their names from fords crossing the River Cherwell, which were mainly used at harvest time. At Domesday, two brothers each owned a mill 'at Heyford', indicating that they were not yet two separate villages. One mill was rated at 12s with two fisheries and 900 eels, and the other at 20s. A century later, each parish had acquired a manor house, a rectory and a church dedicated to St Mary.

In the twelfth century, Upper Heyford was known as Heyford Warren in recognition of its landlord, Warin Fitzgerold, and it wasn't until the fifteenth century that its present name began to appear in records. In 1790, when the canal reached the village, the river was re-routed to the west side of Upper Heyford and the mill and mill house were relocated there. Only two locks – Heyford Common Lock and Allen's Lock – were required for the canal to proceed along a fairly flat stretch of land extending from Somerton. The old ford was obliterated during its construction. The railway line on this section is carried on an embankment a little further west, to avoid being submerged during floods.

In 1863, a local butcher, Noah Austin, brutally murdered a miller, James Allen. He was found guilty and sentenced to death, despite a last minute attempt to blame the miller's daughter, with whom he was in love, for instigating the crime. She hotly denied

A view looking down to the river at Upper Heyford.

this and her compelling version of events was believed to be true. His was, in fact, one of the last public executions to take place in Oxfordshire. The mill remained active until 1910, when it was deemed to be no longer viable and demolished.

Overlooking the canal, Upper Heyford's church was consecrated in the twelfth century but it seems to have been somewhat neglected over the years. Any repairs carried out were only perfunctory so that by the nineteenth century, the whole church had to be completely rebuilt and restored in its original medieval style.

Today, the only remaining part of the original building is the tower. Many of the village's old houses and cottages are two storeys and built of coursed rubble. A street of thatched, stone cottages leads down to the canal with views across the valley to Steeple Aston.

In the fourteenth century, many village properties were owned by New College, Oxford (as some still are today), which was founded by William of Wykeham, who lived at Adderbury. A fine medieval tithe barn, measuring 120 feet by 20 feet and used to store harvests, is also believed to have been built by him for the college's use. It is said that New College took such an interest in Heyford Warren that the wardens and the fellows were frequently entertained at the manor house and rectory. In the nineteenth century, on land donated by the college, the Earl of Jersey (who also had interests in Somerton) paid for a reading room to be built. These were popular places for men to visit, relax and smoke their pipes.

In the fourteenth century, the Black Death caused a serious labour shortage, resulting in a lot of land being neglected. At the same time, rents were increased so that remaining tenants were unable to pay their taxes. New College also suffered losses, as there were

reports of its fishponds by the mill being poached. Gradually, land was brought back into cultivation and very little change took place in its distribution until the nineteenth century, when most farmers changed over to sheep farming. Apparently, the village was noted for its turnips as well as barley and sheep, but in the twentieth century, a considerable amount of acreage was lost when an airfield was constructed.

A mile or two south of the village, along a narrow road with high hedges – spotted in the summer with white convolvulus – is a former airbase. In 1915, 160 acres of farmland was first earmarked for this site and by 1918 it was fully operational. In the same year, the Air Ministry authorised a formation of two squadrons; one for fighters and one for two-seat day bombers, both of which were disbanded after the end of the First World War. It was used by the Royal Flying Corps as a bomber base during the 1920s. After extensive alterations, it received many visiting squadrons not only for training but also for air displays and competitions, particularly long-distance, non-stop flights. All these early aircraft were bi-planes, equipped with propellers and only achieving a speed of about 135 mph, which seems laborious by today's standards.

During the Second World War, this base was used by RAF Bomber Command for training crews to operate Wellington and Mosquito aircraft. After the war, a parachute training school functioned here until 1950, when the base was assigned to the United States Air Force. They remained at the base for more than forty years, bringing their progressively enlarged bombers. Steeple and Middle Aston were directly under their flight path, and folk today can still remember the noise of these great aircraft as they thundered overhead. Fighter planes then arrived at Upper Heyford, in particular F-111s, which became a familiar sight in the county's skies. These were later fitted with afterburners for extra boost on take off, causing even more noise below their flight path. By 1994, due to a change of international policy, aircraft and their pilots were recalled back to the USA and peace reigned once more in the valley. Men and their families had lodged in surrounding villages and been good neighbours. They had brought trade to local shops and pubs and made many friends, so there was a certain sadness to see them depart.

At one time during the 1980s, close to the runway and hidden in a small lane between two hedges, a number of determined people were encamped and permitted to peacefully protest the possible use of nuclear weapons. Eventually, after it was decided that there was no longer a threat, the protesters departed. Ever since the base was disbanded, there have been many discussions and ideas put forward for its future. In the meantime, some accommodation and light industry has been allowed to remain.

Having passed the former airbase, a road runs due south along the route of Portway, a pre-Roman track running parallel to the river between both Heyfords and Kirtlington. Lower Heyford is slightly larger than it's 'twin' and until it and Upper Heyford were given separate identities, was quite frequently called Heyford Purcell. It is possible that there was a connection with the village of Newton Purcell (also at one time part of Bishop Odo's estate) north-east of Bicester and named after a twelfth-century Purcell (or Purcel) family. One cottage in the village is in fact named Purcell Cottage. Excavations south-east of Heyford have revealed a Saxon burial mound and as it appears that there was always a good water supply, it may well have been in constant occupation since the sixth century.

With the river and canal to the west, the village is bounded by a Romano-British earthwork, Aves Ditch, to the east. The earthworks run in a straight line from Kirtlington through to Souldern and can be glimpsed from a sharp bend of the B4030 to Bicester. It also marks the western boundary of the village of Middleton Stoney, which lies at a crossroads a few miles further on. The Jersey Arms public house occupies this corner and, opposite it, ornamental iron gates supported by pillars topped with Grecian urns identify the entrance to Middleton Stoney Park.

Through these gates, after a short distance along a gravel drive, a tree-covered mound is all that remains of a motte and bailey castle dating back to the thirteenth century, while the parish church of All Saints stands isolated in a clearing close by. From here, a private, tree-lined carriageway leads towards a distant main house and outbuildings concealed by walls and gardens. In the 1970s and 1980s, excavations near the church revealed signs of a considerable Roman presence, with foundations of farmhouses, pottery and domestic debris confirming that this was an important agricultural area that would have conveniently served their military base at Alchester to the south-west. This site was where an original Romano-British village with manor house and cottages grew up, until the whole village was moved in the nineteenth century.

The Earls of Jersey are generally connected with Middleton Stoney, the family having lived here continuously for 200 years. In the seventeenth century, a new manor house was built away from the village. This was later burnt down and rebuilt during the time of the 3rd Earl, but most significant was the 5th Earl (1773–1859). It was this Earl, with his Countess, Sarah, who decided to move the entire village around the church to new houses outside the park boundary in order to improve the approach to their mansion.

Lady Jersey had very determined views about education and funded several schools in the area, both here and at Somerton. She came from a wealthy family and put her inheritance to good use in many other charitable ways, so much so that after her death, the inn at the crossroads changed its name in her favour from Eagle and Child to the Jersey Arms. The next countess, Margaret, married to the 7th Earl, was a great traveller during the 1920s and 1930s, venturing to many far-flung places. At home she was an energetic socialite, related to the Saye and Seles at Broughton and enjoyed the company of the Dashwoods at Kirtlington, among others.

It was the 9th Earl who, in 1934, decided to demolish the house and construct a new one designed by Sir Edwin Lutyens (famous for the Viceroy's Palace in New Delhi). A few years later, the building was taken over as a military hospital during the Second World War. On the far side of the churchyard, a space was designated to the War Graves Commission for a small cemetery and twenty-seven airmen and one naval officer from Canada, New Zealand and Britain are buried here, their names and details inscribed on Portland stone headstones.

The River Cherwell takes several wide sweeps across water meadows between the Heyfords and only touches on the canal and villages occasionally. Heyford Bridge was first recorded as crossing the river where it enters the parish from west to east in 1255. In 1793, the road that it carries from Bicester to Enstone became a turnpike with toll gates at each end of the parish. In early 2008, a whole section of road had to be closed

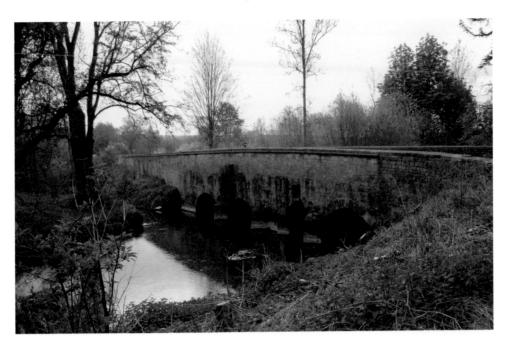

Heyford Bridge.

for three months while both bridges over the canal and railway were taken down and rebuilt. This caused much disruption for local traffic as the valley could only be crossed in two other places: Somerton or Enslow. From the river bridge, some fine views of Rousham House, home of the Cottrell-Dormers, can be seen.

In medieval times, Corpus Christi College in Oxford owned some Heyford farms and land. In the seventeenth century, the college was selling small quantities of timber, mostly elm and ash owing to a general shortage at a time when shipbuilding was paramount. Any woodland that survived was subsequently felled in 1846/47 to make space for the railway. By the nineteenth century, the college still held some land, as did Lord Jersey of Middleton Stoney and the Cottrell-Dormers of Rousham. In fact, Lady Jersey supported a school at Caulcott for twelve pupils while the older children attended classes at Middleton Stoney, and these arrangements continued until the 1950s.

An old manor house, church and rectory are grouped together in Lower Heyford village centre. Most of the houses and cottages are two storeys with thatched or tiled roofs and built of local ironstone. A piece of stained glass portraying a pelican, the crest of Corpus Christi, was removed from the rectory while it was being enlarged in the sixteenth century and placed in a window of the church of St Mary. In Oxford, near the entrance to their college and acting as a sundial, is a tall column surmounted by a pelican with outstretched wings, piously wounding her breast to feed her young.

Lower Heyford mill operated for many years until it was discovered that there was no longer a sufficient fall of water for it to remain economical. New machinery was installed in 1858, but by 1873, it was proved ineffectual. A steam mill was then built alongside the road to Upper Heyford, but even that appears to have ceased working by

The Corpus Christi pelican.

the 1890s. The old mill building, now screened by trees, has long since been converted into a private home.

In the late sixteenth century, a meadow in Lower Heyford was causing some controversy with Steeple Aston, situated a short distance westwards. It seemed good pasture was scarce at Heyford, and Broadhead meadow had been awarded to Corpus Christi as they were landlords of the village and entitled to both hay and rights for grazing after hay harvest. The trouble was that Aston farmers could get their cattle into the meadow in time of flood when Heyford men could not. It was blamed on the alteration of the main watercourse when both mills had been moved. A compromise was finally agreed when the Heyford farmer was allotted the hay and allowed to use the meadow after hay harvest until 8 September, and the Aston farmer from 8 September to 25 March.

In 1790, this section of the Oxford Canal was completed and an important wharf built for off-loading coal from the Midlands. By the 1950s, traffic on the canal had pretty well ceased, although the coal yard was still kept open. Heyford Wharf remained a working boatyard and has since been taken over by Oxfordshire Narrowboats, a boat hire company with a large selection of narrowboats to hire for holidays or days out on the canal during summer months. A shop is conveniently located by the canal as is Kizzies, a small restaurant serving light refreshments.

In the early 1800s, the vicar of the parish, William Filmer (1797–1830), was noted as an experimental farmer by introducing some innovative farming equipment. It is listed that he used 'the Staffordshire two-wheeled plough and the Kentish one-row drill'. He was also responsible for introducing 'a six-course rotation of crops, [he] was fully aware

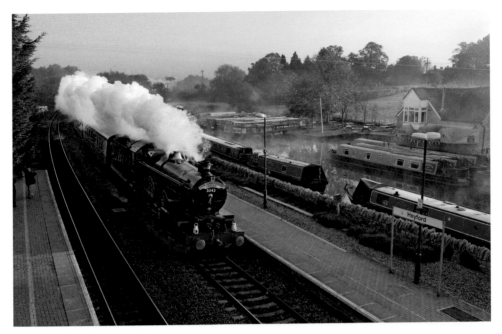

A steam train passing canal at Lower Heyford. (Photograph courtesy of Steven Dance)

of the value of swedes and sainfoin, grew lentils for hay and bred Leicestershire sheep and Berkshire pigs'. As the population was increasing, his methods were probably much encouraged but, later the same century, the population greatly declined due to changes in the occupational pattern with the coming of both canal and railways.

Lower Heyford station is third on the line between Banbury and Oxford. In October 2011, the *Earl of Mount Edgcombe* (with carriages) passed through here while celebrating the 80th anniversary of the Oxford University Railway Society. Back in 1850, it was cheaper to build the line in a curve alongside the canal rather than through the village centre. On opening day, 2 September, which happened to coincide with Feast Monday (an annual event in many villages celebrated with a pig roast or decorated boar's head), a sawyer named David Kirby from Upper Heyford was the first person to buy a ticket to Oxford.

Imagine the excitement when a huge iron monster belching smoke was seen approaching the platform. Dignitaries and local folk were there, waving flags to witness this auspicious occasion and those brave enough to risk life and limb were going to experience a journey like no other. Travelling to Oxford on foot or horseback took several hours in those days, but now a train could whisk you there in a matter of minutes.

The Astons and Rousham

'Up the steep hill to Steeple Aston' was how some old folk referred to the village because it lies on an escarpment high above the Cherwell Valley on the very fringe

of the Cotswolds and in line with its smaller sisters, Middle Aston and North Aston. An Iron Age burial site near Hopcroft's Holt at the south-west corner of the parish provides evidence of an early settlement. In 1658, a plough uncovered the remains of a Roman tessellated pavement, and some coins of Roman origin were found in 1875. In 1997, foundations of a Roman road were discovered when a field was being prepared for new houses in the village. Archaeologists thought that this could well be an offshoot of the Icknield Way, which ran between the Wash and Salisbury Plain. At the same time, six skeletons were unearthed – one of them a child – that may have been from Roman or even Saxon times. At Middle Aston, some loom weights and a whole assortment of pottery shards have been unearthed.

Between 1793 and 1876, the Banbury to Oxford road was turnpiked and the crossroads still remain an important link both west to east and north to south. The Holt Hotel was built as a staging post in 1475. Its inn sign depicts Claude Duval, a notorious highwayman who used the inn as a hiding place. He would charm ladies in their stagecoaches and they said it was almost a pleasure to be robbed by him. He was finally tracked down to a tavern in Chandos Street, London, and arrested while apparently too drunk to resist. In January 1670, he was found guilty on several counts and sentenced to death by Judge Sir William Morton of Kidlington. Many of his lady victims pleaded for his life, but no pardon was granted and he was hanged at Tyburn.

In the seventeenth century, the Holt Hotel was known as the Kings Head, and when the thatch roof was replaced by Stonesfield tiles, lucky charm mud cats were found still in good condition in the attic. They may have been placed there as an insurance against evil deeds, but they failed in their purpose on the night of 18 January 1754

The Holt Hotel sign
at Steeple Aston.

when an unsolved murder took place. A robber broke into the house, clubbed to death the innkeeper, William Spurrier, and his wife, Elizabeth, and stole some money kept in a box and an old teapot. The couple were buried in the churchyard and the inscription on the tombstone (now almost illegible) reads that they were 'in the 77 year of their ages'.

Mr W. E. Gladstone, one of Queen Victoria's prime ministers, is reputed to have stayed at the hotel. According to entries in his diary, he left Oxford between 5.00 a.m. and 6.00 a.m. on 25 June 1830 to walk to Leamington Spa. After 15 miles he was caught in a thunderstorm and 'obliged to put in at a country inn at Steeple Aston' where he stayed the night before resuming his journey the next morning. Departing at 7.00 a.m., he breakfasted at Banbury and continued a further 22 miles, arriving at Leamington by 3.00 p.m.

All three villages (as part of Bishop Odo's estate) are mentioned in Domesday with details of land held, but only North Aston had a mill with a fishery at 30s. This is the same mill that has been referred to on the edge of the parish of North Aston across the valley from Somerton. In the thirteenth century, Steeple Aston managed to acquire its own mill by damming a small stream that traversed the village from west to east.

Most older properties in the Astons are built out of local creamy-grey stone, some darker, some lighter, and a sprinkling of brick houses provide variety. The church of St Peter and St Paul is built out of the same stone and dates back to the twelfth century. Three centuries later, Brasenose College, Oxford, became patrons of the living and have appointed rectors to Steeple Aston ever since. The college name is translated as 'brass nose', taken from a thirteenth-century sanctuary knocker, which is still mounted

Steeple Aston.

in the dining hall beneath a portrait of William Smith, Bishop of Lincoln, who was Chancellor of the University from 1500 to 1503.

One of the first rectors (and the most memorable) was Dr Samuel Radcliffe (principal of Brasenose from 1614 to 1648). During his time in Steeple Aston he founded and gave his name to a village school and a master's house. In his spare time, he obviously enjoyed 'taking the waters' and often used to ride over to King's Sutton for that purpose. Dr Radcliffe also endowed two almshouses for deserving parishioners and, after his death, a trust was set up to maintain these buildings. The school has survived well and been a popular choice for parents over the years, attracting pupils from a wide area in the county.

The principle treasure of the church is the cope (a long garment worn by a priest with both fronts held together by a morse or clasp), and it is considered to be one of the most beautiful examples of English medieval embroidery. Its beauty lies in delicate silk needlework depicting angels and biblical characters worked in silver and gold thread. Its value is such that for many years the Victoria and Albert Museum in London has kept it on permanent loan for safety. Occasionally, it has been returned to the parish for special events and put on public display.

One outstanding feature in the chancel of the church is an imposing monument to Judge Sir Francis Page, a colourful character who lived at Middle Aston House in the seventeenth century. He had a reputation for coarseness and brutality and was known as the 'Hanging Judge' because he had no scruples about sending a criminal to the gallows.

Hendrik Scheemaker was a celebrated Dutch stonemason living in England when the judge commissioned him to carve a life-size monument of himself and his second wife, Frances, in white marble. It turned out that because he did not make a final payment, Scheemaker retaliated by omitting to carve a wedding ring on the lady's finger.

The judge died childless and his Middle Aston estate passed to a great-nephew. He was obliged to change his name to Page in order to inherit and, after he died, Sir Clement Cottrell-Dormer bought the estate, demolished the house and rebuilt it.

A further tale is told about the judge. His ghost is said to be put into a beer barrel every Midsummer Night and chased round Middle Aston's lake by owls. These nocturnal birds were said to represent ghosts of widows of the 100 men that the judge had ordered to be hanged.

There has been a manor house at Middle Aston since Domesday, with several changes of ownership over the centuries. It has served frequently as a manor house for Steeple Aston where, despite there being several fine country houses, none were ever considered suitable for its lord. At one time, a road running north from Steeple Aston was a bridleway that stopped at the gates to the house, and it was only in the nineteenth century that a modern road was built leading into the village.

It is curious to note the changing fortunes of Middle Aston compared with those of Steeple Aston. In the Middle Ages, Middle Aston appears to have been more densely populated and, during the time of Judge Page, he was the sole landowner of the hamlet. This enabled him to enclose the land without any question, dividing the area into three farms: Grange Farm, Town Farm and Great House Farm, these last two

becoming amalgamated soon after. One hundred years later, a tenant farmer of the whole of Middle Aston was William Cother, a celebrated breeder of Cotswold sheep and Hereford cattle.

By 1861, Charles Cottrell-Dormer owned every single house in Middle Aston on top of his ownership in Steeple Aston, where no cottage in the entire parish was owner-occupied and most of the landlords were non-resident. The village had been enclosed in 1767, with the rector and Cottrell-Dormer sharing much of the acreage, but by the nineteenth century, poverty seemed to be a real problem. Many families complained that they could barely subsist and hayricks were burnt down in protest – one labourer is even known to have been tried and hanged for the incident. The church was so worried about all this that some households were absolved from paying rates and other families were given the opportunity to emigrate to manufacturing districts in different parts of the country or even abroad.

Several larger houses in Steeple Aston that were originally owner-occupied have been divided into apartments over recent centuries. Hill House was first mentioned in the seventeenth century when John Davis lived there, while his brother, Thomas Davis, resided in a slightly larger house, The Grange. The pair were known as Davis-on-the-Well and Davis-on-the-Hill. For the next 200 years, the Lechmere family occupied Hill House, firstly by Admiral Sir William Lechmere RN, then his son, also in the Royal Navy, and then succeeding prominent civilian members of the family. In 1932, Henry Mark Beaufoy, who for many years acted as Oxfordshire High Sheriff, took up residence and his was the last family to live here. It then became a boarding school for a time and, on another occasion, accommodated a racing stable, with one of the horses named Hill House gaining notoriety for winning a controversial race in 1967. Finally, the house was put on the market once more and, after being sold, divided into flats.

A similar fate befell The Grange, where several families lived until the 1960s. The most enduring was Captain Richard Bradshaw, who purchased the house in 1870 and later became Vice-Admiral of the Fleet, succeeded by his youngest son Arthur, known as Moses. The last member of the family, Eira, who had previously moved to Cornwall, died in 2009. By the 1960s, the house had been sold and divided into four apartments and, over the next few decades, thirty-seven modern houses were built within the grounds.

Cedar Lodge on North Side is notable as Steeple Aston's Women's Institute held their first meeting there in 1918. This movement, which had only recently been mooted in Canada, swiftly crossed the seas to a small village in Wales and from there it was carried to Oxfordshire. For thirty years between the 1960s and 1980s, Cedar Lodge was the home of Professor and Mrs Bayley, better known as the distinguished novelist Iris Murdoch.

Most of the old houses and cottages in North Aston are arranged around a village green. This probably used to be much larger and, in the seventeenth century, after the enclosure acts, it became a common grazing ground for sheep and pigs. The village, however, was evidently famous for its orchards and in particular an apple called 'Nonpareil', which, in 1593, was reputed to have been brought to England from Normandy by the then occupant of North Aston Hall, Colonel Edward Vernon.

It came to be known as 'The North Aston Apple' but today, no trace remains of apple or orchards, unless a descendant may have survived in a different guise in some gardens. In the 1980s, part of the park was sold to Roderick Nicholson of Steeple Aston to establish Nicholsons Nurseries, a garden centre that continues to trade successfully today.

Over the centuries, several families have resided at North Aston Hall and the manor house, enjoying commanding views across the Cherwell Valley. The Bowles family was one that made quite an impact in the village, with several generations of them owning the hall for over 100 years. In the mid-1700s, Oldfield Bowles was apparently a keen artist and had friends among many well-known painters of the day, including Thomas Gainsborough and Sir Joshua Reynolds. In the Wallace Collection in London hangs a painting by Reynolds of three-year-old Jane Bowles, Oldfield's daughter, sitting on the ground and clutching her little black and white spaniel. In the 1990s, a Mr and Mrs Gillan by chance purchased a print in an Oxfam shop in Knutsford. On the back in faint writing was the inscription 'Jane and Venus reposing'. But long before this, Jane's brother inherited the picture and sold it to the Marquess of Hertford. His extensive gallery of paintings in Hertford House, London, was opened to the public and renamed as the Wallace Collection in 1900.

Oldfield Bowles unsurprisingly created a fair-sized picture gallery at the hall. Besides his affection for art, he was extremely fond of amateur theatricals and, in a specially constructed theatre, many a performance took place with all the family joining in. Apart from his leisure achievements, he was a progressive and experimental farmer, trying out the latest techniques on his land at North Aston. His methods vastly improved the condition of the soil, which led to increased weights for his cattle, thicker fleeces for sheep and better yields of corn. In 1798, there was a lot of unrest in the county and Yeomanry Troops were raised to maintain order against the riots that were breaking out. Of the four Yeomanry Troops, the Wootton Troop pertained to the Cherwell Valley and Oldfield Bowles volunteered to be in charge. Extravagantly dressed in a blue uniform with white facings and white breeches, a large white scarf at the neck, topped by a black leather cavalry helmet with bearskin crest and side hackle plume and astride his favourite horse, he would indeed have cut a fine figure. When he died in 1810, the Wootton Troop accompanied his funeral hearse all the way from Oxford to North Aston.

Although he had many children, he had only one son, named Charles Oldfield Bowles, who also grew up to be a painter, exhibiting several times at the Royal Academy. But their prosperity did not last forever, their wealth having been founded on the slave trade in the West Indies, and Grange Farm had to be sold in 1823 and the hall was let to a succession of tenants.

After the Bowles family, the hall was purchased by William Foster-Melliar, who was to live there for forty-four years. A keen follower of the Heythrop Hounds, he hunted four days a week until the day he died in 1906. One of his greatest achievements was to become sole freeholder of a 40-acre meadow beside the River Cherwell. Until then, both the vicar of Duns Tew and the squire had the right to crops of hay growing there, and it had been a controversy for years as to whom the rates for it were due.

Foster-Melliar, while he was squire of North Aston, made many improvements to the village, including building new cottages, converting an original coach house into a school, restoring the fabric of the church and erecting a fountain. The fountain was a gift from him in 1863, and was originally fed from a reservoir by the Fox Inn at the North Aston-Duns Tew crossroad. It provided water for humans from its tap, horses from its trough and dogs from an overflow at its base. It later fell into disrepair until it was restored to its former glory in time for the Millenium celebrations.

The twelfth-century church of St Mary stands in close proximity to the manor house, indicating that it once served as a private chapel. Inside are memorials to many families who have been benefactors of the parish. In 1984, the living was combined with the benefices of Steeple Aston and Tackley.

The Cottrell-Dormers at Rousham have, for many years, been connected with the Astons. The family was first heard of in the mid-1630s, when Sir Robert Dormer had a house constructed in Tudor style at Rousham using Oxfordshire stone. During the Civil War, Sir Robert and his son may have had different allegiances as the Royalists did a great deal of damage to the building while on their way back to Oxford in 1644. In the following year, a small force of Cavaliers occupied the house and the gun slits they cut in the main front door to help with defence are still visible, they too probably caused much damage while in occupation.

Several Dormers followed and, in the early 1700s, General James Dormer employed William Kent (1685–1748) to remodel and enlarge the house and design some new gardens. These were on a grand scale with views stretching down to the River Cherwell. A ha-ha (a ditch surrounding a garden in place of a fence or wall) was created to give an impression that the north-facing fields dropped down without interruption

Rousham House.

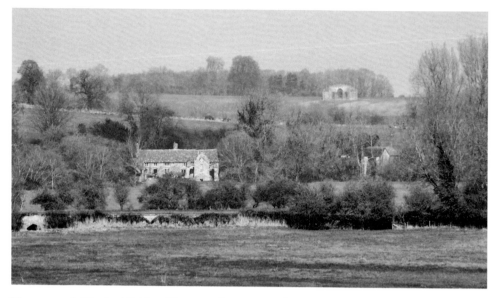

View towards Heyford Bridge. (Photograph courtesy of Jenny Bell)

to Heyford Bridge. Elsewhere, ponds were created, temples erected and statuary placed at different viewpoints. In 1728, it was commented that the gardens were 'the prettiest place for waterfalls, jets, ponds, enclosed with beautiful scenes of green and hanging wood'. This quotation can possibly be attributed to Horace Walpole, who spent much time here and greatly admired Kent's work.

William Kent started life as a coach painter and then became one of the first architects of garden design using a landscape style. He had an immense influence on those who came after him, including 'Capability' Brown. It was a time when naturalistic landscape became fashionable, following classical views of Roman countryside as painted by such artists as Claude and Poussin.

Near the house are a twelfth-century church dedicated to St James containing memorials to the Cottrell-Dormer family; a seventeenth-century walled garden with an impressive, long, herbaceous border; extensive kitchen gardens; a dovecote built in 1685, which still retains its original circular ladder; and stables, which may also have been designed by Kent. Another of his designs was an eyecatcher – a three-arched folly high on a hill bordering Steeple Aston – and was to be seen in a direct line between Rousham House and Aynhoe Park. There was a good reason for this as both families were related by marriage. Cuttle Mill near Heyford Bridge was also 'gothicised' as another eyecatcher to match the rest of the property.

A cousin, Sir Clement Cottrell, was next to inherit, his son later combining both names to become Cottrell-Dormer. By the nineteenth century, the family owned land and property in Steeple and Middle Aston. Middle Aston House changed owners several times and various alterations were made. In the twentieth century, it was bought by the Robson family, who later sold it to Spillers Ltd food manufacturers and moved to Kiddington near Middle Barton. By the turn of the century, it was taken over by part

Longhorn cattle.

of Pera Innovation Network and renamed Middle Aston Leadership Centre. It remains a dedicated residential training and development centre.

The Cottrell-Dormers still live at Rousham and, as well as caring for house and gardens, have always been farmers, raising cattle and growing arable crops on their land. Longhorn cattle, which have been a specialty of theirs, can often be seen in fields surrounding their property. The Longhorn was Britain's first true cattle breed and was developed in the eighteenth century by Robert Bakewell of Leicestershire for its lean meat; they are distinguished by the dramatic downward curving of their horns. Some attractive stone cottages make up the hamlet of Rousham, all of which lie within the grounds and are let to tenants.

The gardens at Rousham are open to the public most days and continue to be a popular and tranquil place to stroll around. Picnics are encouraged but there is no teashop and no young children or dogs are admitted.

Tackley with Northbrook

Two miles downstream from Rousham, Northbrook Bridge was originally a packhorse bridge built in stone over the River Cherwell. However, when the Oxford Canal was being constructed, a second stone bridge was added to accommodate the canal. At this point, the river and canal are very close together, and a short distance west of their banks, the parish of Tackley is reached. Domesday mentions a mill at 10s for Tackley and possibly one other, but no trace of them remain.

Situated well east of the A4260 Banbury to Oxford road, in the historic part of Tackley, an eleventh-century church, dedicated to St Nicholas, shares its living with

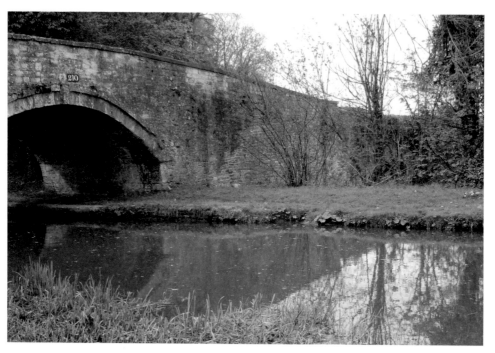

Bridge over canal and river at Northbrook.

The Battle of Tackley was probably fought near this bridge.

Steeple Aston. Nearby are the remains of two seventeenth-century manor houses, one of which contained an interesting pigeon house. Other old houses and stone-built cottages are attractively grouped around a triangular village green.

During the Civil War, a skirmish referred to as the Battle of Tackley is recorded as having taken place on the banks of the River Cherwell, but there is no record of how long it lasted or if there were any casualties. However, some years later, a real disaster for the village occurred.

In the nineteenth century, there was an increasing amount of poverty in Britain and families were being encouraged to migrate to Australia where there was a shortage of labour. Many ships left British ports during the 1840s carrying whole families on assisted passages who were seeking a better life 'down under'. On 20 April 1845, the barque *Cataraqui* sailed from Liverpool with 367 passengers and 41 crew on board (some sources state 369 passengers and 46 crew), bound for Melbourne. From Tackley came six families, the largest being two brothers and their wives, with nine children between them.

All went well throughout the voyage until the night of 3 August as the ship was about to enter the Bass Strait between Tasmania and the Australian mainland. Storms and heavy seas had raged for the last few days and all on board were anxious to get ashore and settle into their new homes.

But this was not to be. *Cataraqui* foundered on the rocks and, in mountainous, crashing waves, started to break up. People and goods were thrown around like matchsticks and when morning dawned there was very little sign of life. Her captain and most of her crew were drowned, together with the passengers. Nine people survived and only one of those was a migrant. Documents providing details of this tragedy are still held in Liverpool archives.

It so happens that Tackley is famous for possessing some of the earliest and latest technology. Of national importance but on private land, a group of fishponds are listed as an ancient monument. Through a stone archway, an avenue of lime trees leads to an area of some 6 or 7 acres containing three (with space for a fourth) roughly triangular ponds, each with a central island. They were created in the early seventeenth century by the then Lord of the Manor to supply water and angling facilities for the village. They are fed by a natural spring and regulated by a number of sluices, the water finally flowing out into the River Cherwell. To curb the ever-encroaching undergrowth, negotiations are underway by the present owners, who hope that extensive restoration work may be carried out in the coming years. Modern technology is represented by some huge satellite dishes constantly sending and receiving messages from around the globe, which are built into a fold of the hills near the river and canal.

Tackley is the next stop on the line between Banbury and Oxford. This section of the GWR was built in 1848/49. The nearest station at that time was at Enslow by Bletchingdon until 1931, when Tackley Halt was opened. Trainloads of wagons are believed to have carried slate here for re-roofing cottages that had previously been thatched. As the river leaves the canal at Pigeon's Lock, south-east of the village, it forms a mill pond and weir perfectly suited for eel traps. In the seventeenth century, the house was renamed Flight's Mill when Francis Flight, a doctor and miller, purchased the property. A Victorian eel trap

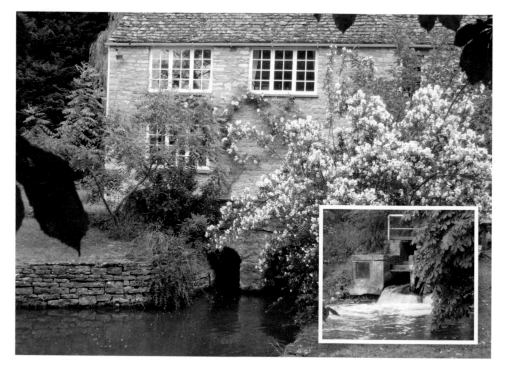

Flight's Mill near Kirtlington with eel trap (*inset*).

replaced the medieval one and was controlled by sluice gates; the rushing water trapped eels in a concrete box with a grill on one side through which the excess water escaped. The mill itself operated until the 1970s, generating electricity stored in huge batteries behind the house. These were later removed after becoming redundant.

Kirtlington and Bletchingdon with Enslow

From Pigeon's Lock, Mill Lane runs eastwards towards Kirtlington and, just before the village, a gateway connects to an old quarry where dinosaur bones and fossils have been found. Similar to the quarry at Ardley, many different types of seashells, corals and seaweeds have been found here and added to the collections in the Oxford University Museum. Down the road from Kirtlington to Enslow is another quarry, which was closed in 1927 when the Shipton Cement Company took over part of the site. It was started before mechanical excavators were available and most of it was dug out by hand with picks and shovels. It changed hands several times until the cement works finally closed in 1986 and it was deemed to be a Site of Special Scientific Interest. Since then, it has been developed as a nature reserve by Cherwell District Council. Its tall chimney is visible for miles around and although the area lies empty and derelict, birdwatchers love to wander through here as many different species have taken advantage of this quiet spot.

The now silent chimney of old cement works.

Linking London with the Fosse Way at Cirencester, Akeman Street, having left Alchester and skirted Chesterton, bisects Kirtlington from east to west. It crosses over the River Cherwell at Pipe Bridge and continues on through Tackley, before heading westward through Woodstock Park. Where it crosses the main A4260, it passes quite close to Sturdy's Castle, a country inn that offers accommodation and meals. As a diversion, guests have sometimes been invited to submit ideas as to who Sturdy was and why he needed a 'castle'. Many colourful suggestions have been put forward, but perhaps a less inventive version is the correct one. It has been recalled that, at one time, the pub was jointly owned by a Mr Sturdy and a Mr Castle. But these two gentlemen fell out one dark night. It ended in blows and for many years the inn sign (inscribed 'Sturdy and Castle') depicted one of them with a raised gun and the other on the ground pleading for mercy.

Kirtlington is chiefly recognised as home of the Dashwood family, who have lived here since the eighteenth century. Their history is legendary in the county as they owned much land and were active and conscientious landlords, particularly in their own parish. They first lived at Northbrook House (near the bridge) before Sir James Dashwood built his Palladian country house at Kirtlington and employed 'Capability' Brown to landscape its grounds. There is no trace of the original house and it is said that Sir James may well have removed all its masonry in order to construct his new residence. Northbrook Farm today consists of a farmhouse, farm buildings, some cottages and an old walled garden. The land is used for arable crops

Former inn sign for
Sturdy's Castle.

as well as grazing for sheep and cattle and both the canal and railway run through
its fields.

Kirtlington Park is well known for polo matches played during summer months
and many famous names come here for their entertainment. Polo is one of the oldest
games in the world, originating in Persia and slowly spreading all over Asia until it
reached India in the nineteenth century. It then became highly popular with the
British and Indian armies, who introduced it to England. In 1874, the Hurlingham
Club was formed and rules for the game were laid down. Nowadays, its popularity is
undiminished and many clubs play tournaments around the world. There is also a stud
at Kirtlington for various breeds of horse, which can be glimpsed occasionally in the
surrounding meadows along with those occupied by grazing cattle.

Early farming in the village consisted of open fields divided into strips. This lasted
up until the early part of the nineteenth century when a Private Act of Enclosure
was granted to Sir Henry Watkin Dashwood in 1811. The 'open fields' were then
transformed into small fields with hedgerows and, as there was evidently no opposition
(as there was in other parishes), it can be assumed that villagers were content at being
allowed sufficient grazing land for their needs.

Domesday records a parish church, but the oldest part of St Mary the Virgin is the
early twelfth-century Norman arches that support a bell tower. Over the years, much
restoration has been carried out and part of the church was converted into a chapel
and burial vault for the Dashwood family.

A medieval celebration called 'Lamb Ale' was traditionally held on the Monday
after Whitsun. Village maidens with hands tied had to race after a lamb, the winner
catching it in her teeth. This was followed by 'dancing, mirth and merry glee'. Next
day, the lamb was 'part bak'd, boyld and rost, for the Ladies feast'. Festivities such as
this, along with Morris dancing, were banned under the Puritans as they disapproved

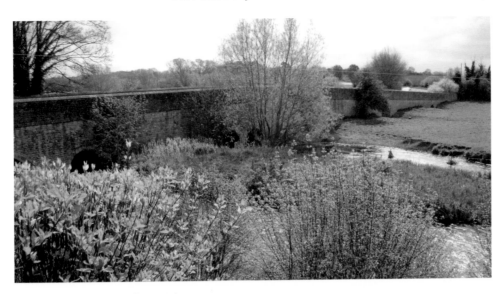

River passing under Enslow Bridge.

of most amusements they considered would encourage drunkenness and immorality. In 1660, after the monarchy was restored, both traditions were revived. By the late nineteenth century, the 'Lamb Ale' was replaced by a feast with a toy lamb instead of a real one. In 1979, Morris dancing was revived so part of this old festival is again celebrated each year.

Bletchingdon, a few miles south east of Kirtlington, is a long, straggly village with its main road leading down to Enslow Bridge, carrying the road from London to Chipping Norton, and one of only a few ways possible to cross the Cherwell Valley. The bridge was originally made of wood but was rebuilt in stone possibly when the road was turnpiked in the seventeenth century. The village houses of Bletchingdon were originally grouped around a green but in the sixteenth century, the cottages on the north side were destroyed to facilitate the expansion of a manor house and its grounds. Opposite its main gates is The Blacks Head public house, the name being a reference, it is thought, to the Dashwoods of Kirtlington's black manservant.

Domesday recorded a mill at Bletchingdon, a mile or two east of Enslow, at 7s 6d. It may have already been a double mill by 1340, but it certainly was one by the seventeenth and eighteenth centuries. A manor house has stood on much the same site since Domesday but it was rebuilt in 1627 with the arrival of Sir Thomas Coghill (the new lord of the manor). In 1644, he may have been slightly surprised when his property was taken over as a Royalist garrison. For 'ye defence of Bletchingdon House' he was allocated a supply of '60 Musketts'. In April 1645, Colonel Francis Windebank was in charge of the house and garrison when, after the battle at Islip, Cromwell took a force of Parliamentarian troops to demand the occupants surrender. Windebank, who had only been married for two years and feared for his young wife's safety, immediately surrendered and they made their way back to Oxford unhindered. He was later shot for his cowardliness and his ghost is said to haunt

Deadman's Walk in the city. As for the '60 Musketts', they probably ended up as a handy addition to the Parliamentarian's arsenal.

Sir Christopher Wren (1632–1723), most famous as architect of St Paul's Cathedral, spent many years in Bletchingdon. At the time of the Civil War, his father was Dean of Windsor and he suffered at the hands of Cromwell's men when some Windsor Castle artefacts were plundered. It was a wise move to leave the area and fortunate for them that Wren's sister Susan had married Revd William Holder, rector of Bletchingdon, who offered the family a home. Christopher Wren, already a keen scientist, studied at Wadham College, Oxford. In 1669, he married Faith Coghill, the second daughter of Sir Thomas, thus keeping up his links with the village.

The manor house was to change hands several times over the following centuries, but perhaps the most significant owners were the Annesley family, who were to live there for nearly 300 years and were much revered as benefactors to the village. Their family tree is highly complex but is fully detailed in the Victoria County History. The Annesleys were an established Anglo-Irish family who were created Earls of Anglesey in Wales in the seventeenth century. In 1780, their home in Oxfordshire was remodelled into its present Palladian style and renamed Bletchingdon Park.

Enslow, a hamlet on the edge of Bletchingdon, grew up as a result of the construction of the canal and railway. In 1787, Henry Baker was appointed contractor for the Enslow section of the Oxford Canal and diverted the river to make way for it but, unfortunately, the drainage system was badly executed and caused much flooding of the meadows in the vicinity. At that time, Henry Baker was landlord of a public house, The Brindley Head, named after James Brindley, designer of the canal. As landlord, he was anxious that navigators, or 'navvies' as they were known, should be able to enjoy a pint of beer after their labours and, consequently, this inn was built specifically for their use.

In 1788, a wharf and wharfinger's house were built and, by the early 1800s, the inn was renamed Rock of Gibraltar. No one knows exactly why this name was chosen and several theories have been put forward. A field across the road from the inn was named Gibraltar on old maps and, at one time, was believed to have been owned by General Roger Eliott (c. 1665–1714). In 1705, he successfully defended Gibraltar from the Spanish. In 1707, he was appointed Governor of Gibraltar but died a few years later from wounds received in previous battles.

Another suggestion offered was that Gibraltar is a rock surrounded by water and the inn was also surrounded by water (the river and canal after Henry Baker's efforts). Another idea related to the fact that ground in this area is very rocky, as evidenced by the presence of several quarries. Nowadays, the inn sign depicts a narrowboat and it has been renamed The Boat Inn.

Completion of the Oxford Canal in 1790 brought cheap coal to the area. By 1850, a GWR section was constructed near to the canal with its station labelled Bletchingdon and not Enslow. It was here one morning in the 1860s, that Mr Chapman, a watchmaker on a botanising expedition with his son, made a most dramatic discovery. Having alighted from a train and left the station, he noticed some workmen in a nearby quarry. One of them was heaving on what looked like a heavy rock when Mr Chapman ordered them to halt as he had recognised that it was not rock but bone.

The bones of a Ceitosaurus were uncovered near Bletchingdon station. This image is a restoration of a Ceitosaurus by Gareth Monger. The living animal was about 15 metres in length.

Further investigation revealed it to be an enormous thigh bone of a Cetiosaurus, a 168 million-year-old quadruped herbivore dinosaur.

The professor of geology and first curator of the Oxford University Museum, John Phillips (1800–1874), was contacted hastily and he came to supervise the removal of the 6-foot bones to the museum. Also removed from the site were some teeth and vertebrae from part of its tail. John Phillips went on to be appointed Deputy Reader to William Buckland (who had created the name of Megalosaurus). After Mr Buckland's retirement in 1856, John became reader and professor of geology from 1856–74. As for Mr Chapman, he no doubt returned to his flower collection and watchmaking business, remaining forgotten ever since.

South of here, the valley narrows and, leaving broad meadows behind, enters into a more wooded area.

Shipton-on-Cherwell, Thrupp, Hampton Gay and Hampton Poyle

Both the river and canal make a half-circle sweep around Enslow and join together after Baker's Lock (named after Henry Baker in recognition of his concerns for the 'navvies') to form one waterway, until separating again at Shipton Weir Lock. First, though, they pass the now derelict Shipton cement works, which once used water extracted from the river and obtained supplies by narrowboat.

As the Banbury–Oxford road nears Kidlington, there are two minor roads running eastwards. The first one leads to Shipton-on-Cherwell, a tiny village with a manor house and a twelfth-century church with an avenue of trees leading to its porch, which is situated on elevated ground overlooking the canal and river. This church has had a chequered career, having had alterations and several dedications until reverting to its original one of Holy Cross. Domesday mentions a mill here at 11s.

The second road leads to the hamlet of Thrupp, past a line of houses flanking the canal, which turns here to approach Oxford along the valley of the River Thames instead of the Cherwell Valley. Domesday records Thrupp as having a mill at 6s and 125 eels. In the eighteenth century, the canal company bought the watermill, demolishing most of it in order to build a row of cottages alongside the canal, once called Salt Row. It is thought that these buildings might have once served as salt warehouses.

In the 1850s, the GWR continued to construct the line past Shipton and Thrupp on its way to Oxford, but in 1874, disaster struck. It was only a few years after the calamity at Aynho when on Christmas Eve 1874, a defective wheel on a crowded London to Birkenhead express caused it to derail as it crossed the canal east of Shipton. Extra coaches had been added to the train to cope with the holiday crowds and, after a short stop at Oxford station, its fifteen coaches held a total of 500 passengers.

The weather at the time was frosty and the canal was covered in a sheet of ice. Several of the coaches plunged down a steep embankment between the rail and canal bridges into meadows 20 feet below. Some landed on their roofs, some on their sides and debris was spilt onto the frozen canal. The two locomotives managed to stop before hitting the bridges and crew members set off in haste to warn any approaching trains of the wreckage left on the track and to seek medical aid. With all the noise caused by the crash, people from far and wide left their homes to help extricate the passengers, and an Oxford surgeon who happened to be treating a patient nearby was quickly on the scene to help. Despite the telegraph lines being down due to so much snow, Lord Randolph Churchill came from Blenheim Palace, accompanied by ladies from the Duke of Marlborough's family. Medical supplies soon arrived from Oxford but when the final toll was taken, thirty-four passengers had died and sixty-five were seriously injured. The then tenant of Hampton Gay Manor, Mr R. L. Pearson, organised his employees to carry the dead across fields to his paper mill behind his house where they were laid out on beds of straw. The wounded were helped to the manor house, which was turned into a makeshift hospital before they could be transferred to Oxford. Officials at GWR set up an inquiry as to the cause of the accident and, after much delay and discussion, it was concluded that it was related to the bad weather conditions that caused the problem with a wheel-tire.

The twin hamlets of Hampton Poyle and Hampton Gay lie further east of the river and canal by Shipton.

> Cherwell winds with devious coil
> Round Hampton Gay and Hampton Poyle.

From a poem by A. D. Godley (1856–1925).

The name 'Hampton' is an ancient English word meaning 'village' or 'farm'. Robert de Gay was one of Hampton's first twelfth-century landlords, and in the thirteenth century, Walter de la Poyle gave his name to the other Hampton. Both hamlets are nearly encircled by part of the canalised stretch of the River Cherwell, which is controlled by weirs of the Domesday mill valued then at 15s. In the fourteenth century, this manor was held by Osney Abbey, as were many other Oxfordshire parishes.

It is recorded that in 1512, and again in 1526, both Merton and Lincoln Colleges bought property (and later some land) at Hampton in order to 'escape the plague'. Perhaps they were scared there might be another outbreak of the Black Death, which wiped out a third of Oxford's population between 1348 and 1350.

Hampton Gay is mostly remembered for instigating an agrarian revolt in the 1500s. In 1596, discontent was growing among poorer families during the time of

The river 'winds with devious coil'.

the enclosures, and most male members of both communities were prepared to march to London to seek assistance. Their anger was directed at Vincent Barry, whose grandfather had made his money from wool and had purchased the manor house in 1544. Vincent had made arrangements so that the E-shaped, three-storey house was divided between himself, his wife Anne, their daughter and son-in-law.

The conspirators were plotting to murder Vincent and his daughter (who would later inherit the house) to avenge the suffering of the poor. Enslow Hill was decided upon as a meeting place, but only 'some ten persons with pikes and swords' turned up, and Vincent Barry was warned of the plot in time. Five Hampton Gay men were arrested and dispatched to London where one of them was sentenced to be hanged and quartered as ringleader. Although their main objective never materialised, all was not in vain as, the following year, measures were put in place to restore some pastureland back to arable. Meanwhile, descendants of the Barry family continued to live at the house until they sold it in 1682.

In 1681, a watermill on the river, originally built to grind corn, was converted into a paper mill, which started an industry that was to last until the early nineteenth century. Over the next 200 years, it had mixed fortunes with changes of ownership, bankruptcy, the uncertainty of the paper trade and fires breaking out. It finally burnt down in 1878. Workers lost their jobs and moved away and their houses fell into disrepair.

It so happened that the previous year, the same fate befell the manor house. It had been substantially built of stone in an isolated position across meadows at Hampton Gay in the second half of the 1500s. After the Barrys left, it changed hands several times

Across the river to Hampton Gay.

until it caught fire, was completely gutted and its roof fell in. Wadham College owned it at the time, having purchased it along with various other pieces of land. Interestingly, the college then sold it in 1928 to Colonel S. L. Barry from Long Crendon. He thereby reacquired it for the same family who had previously owned it for 138 years.

Hampton Gay manor house was never rebuilt or occupied again. Exterior walls are all that remain of the building, which stands forlorn and evocatively stark against the sky. Near the house and overlooking the fateful railway line, is the medieval church of St Giles. It was a silent witness to those tragic events in 1874, and a tombstone dedicated to nineteen-year-old Benjamin Taylor of Wolverhampton, one of the victims of the crash, stands in the churchyard. The church building itself has been altered over the years and underwent restorations in the eighteenth century. Occasional services are still held here today. As for the village, all that can be seen now across a grassy meadow are some hillocks and bumpy ground, concealing vestiges of old foundations of what was once a thriving, bustling community.

Woodstock with Begbroke and Yarnton

The market town of Woodstock (the name from Anglo-Saxon times can be translated as 'a clearing in the woods') is approached from the main Oxford–Banbury road by a series of leafy lanes running westwards between fields of crops and grazing sheep

The stark remains of Hampton Gay manor.

and cattle. The town is generally associated with Blenheim Palace, which lies on its south-west border, but long before the building of this grand edifice, the Romans had made their mark. Akeman Street, which crops up now and again in the valley and runs from Alchester through Kirtlington and Tackley, makes its appearance here, passing through the northern boundary of Woodstock Park on its way to Cirencester.

At Domesday, Woodstock is described as part of 'the lordship forests of the King', indicating that it was sparsely populated at that time. The Black Death, 300 years later, certainly took its toll, as it did in so many other villages in the county. The explanation of a 'forest' in those days is not quite the same as it is today. 'Forest' then referred to an area where the King went hunting rather than a thickly wooded area. 'Wood' was the term used for an area with many trees providing the timber necessary for fuel, and for building houses and ships. During the next few centuries, the 'forest' itself would be teeming with deer, wild boar and other game for the King's sport. A stud for rearing horses used not only for hunting but for transport, haulage and cartage was an important practice and was housed in one area of the estate. In autumn, in return for domestic chores, estate tenants were permitted to bring their pigs to root for acorns and beechmast. Fishponds stocked with fish for royal visits were fed by the River Glyme (a tributary of the River Thames), which runs through the park and a mill, was situated in the northern part of the parish.

The park itself has been the playground of kings for centuries, and a manor house has existed within it in different stages of repair for the royal visitors' comfort. Hunting,

often referred to as the sport of kings, was no stranger here and it has been recorded that in the twelfth century, Henry I, son of William the Conqueror, decided to build a 7-mile stone wall around his hunting grounds. This was extended a few centuries later and can still be seen today, now measuring 11 miles in total. Another reason for the wall was to enclose foreign animals that the king was especially partial to. It is interesting to note that these creatures ended up in the Tower of London and eventually in the nineteenth century, formed the basis for London Zoo at Whipsnade.

Henry I's grandson, Henry II (best known for being responsible for the murder of St Thomas à Becket in Canterbury Cathedral), when not dallying with 'Fair Rosamund' or other ladies, was much in favour of hunting with falcons. Falconry is described as 'the taking of wild quarry in its natural state and habitat by means of a trained raptor'. This ancient sport was popular among nobles in medieval times throughout Europe, Middle East and East Asia, but it more or less died out in the eighteenth and nineteenth centuries. However, a number of clubs around the world now give flying displays to encourage the preservation of birds of prey.

Successive kings and queens have hunted and enjoyed the amenities that Woodstock and the park have provided over the centuries, not least as a sanctuary from the towns that were breeding grounds for diseases, particularly the plague. During the Civil War, Charles I and his retinue arrived here, staying with Prince Rupert and the Duke of York. At one time, a regiment of Musketeers camped in the grounds and spent their days training before being posted off to engage with Parliamentary forces in other parts of the country. The Parliamentarians eventually succeeded in capturing the manor house in April 1646, then ransacked the building, leaving it in a badly damaged state. Despite this, sporadic visits were made here until the arrival of the Churchills, after which the scene was all set to change.

Since the thirteenth century, one of this small town's best remembered crafts has been glove making. Sheep and deer skins could always be found in the park at this end of the Cotswolds, and with many visiting royalty to the palace, these fine leather gloves and belts were made readily available. Glovers generally worked in their own homes or in specially set up workshops. In medieval times, heavy gauntlets and leather breeches were made not only for the military but also for horse riders and falconers. Later on, gloves for cricket and other sports were added to the list, but by the end of the twentieth century, gloves were no longer an essential fashion item and, in 1990, all glove making in the town ceased.

Nowadays, tourism is the main industry and those little shops that line the two main, Y-shaped streets are an incentive for visitors to browse a while or seek a souvenir on their way to visit the palace. A further attraction is Fletcher's House (dating from 1279), now the Oxford Museum, where a full-sized replica of Megalosaurus (as found in Ardley Quarry) stands menacingly among a screen of reeds and bushes in the Dinosaur Garden.

At the west end of Woodstock's main street is an entrance to the park through a high archway. A stunning view is revealed of a spacious grassy area sloping down to a lake spanned by a bridge of immense proportions, designed by Sir John Vanbrugh for the 1st Duke of Marlborough. Water flows smoothly through a huge central archway

The imposing gateway to Blenheim Palace.

A view of the palace and the lake.

flanked by two smaller ones on either side. In the distance, a Column of Victory rises 134 feet high and atop the Duke is depicted as a Roman General accompanied by eagles. His arm is raised in victory as he surveys the scene below, but it is a little ironic that he never saw himself here, as the column was erected a few years after his death.

In the fourth year of the War of the Spanish Succession (1704), John Churchill (1650–1722) assembled his army near Cologne in May in order to march towards Vienna. In June, he joined forces with Prince Eugene of Savoy (1663–1736) and, on 13 August, the Battle of Blenheim turned out to be their greatest military triumph, marking the first significant defeat of Louis XIV's armies. Fierce fighting took place near the Danube around the little village of Blenheim with much loss of life among the soldiers. Although their property was badly damaged, the villagers themselves had wisely fled.

Due his numerous victories in previous battles, John Churchill had already been granted an earldom by William III. When Queen Anne came to the throne in 1702, she created him 1st Duke of Marlborough. But now, as the Battle of Blenheim succeeded in preventing complete dominance of Europe by France, some special recognition was required by a grateful nation. In 1705, the Queen granted him about 1,700 acres of land contained within the park, remains of buildings there and several outlying villages.

The Duke engaged John Vanbrugh to build a house in Woodstock Park as a gift from the nation. A site was chosen opposite to where the old palace lay in ruins, and Queen Anne desired it to be called Blenheim. Parliament provided the original finance but by 1712, when the friendship that had existed between the Queen and Sarah, the Duchess of Marlborough, became strained and fraught following their final quarrel, no more funds were available and debts mounted up. Two years later, building started again at the Marlboroughs' own expense, but it was not until 1719 that the family finally moved into the palace from their temporary house in Windsor Park.

Nicholas Hawksmoor was also involved with Blenheim Palace, but apart from a few exceptions, even the experts find it difficult to determine exactly what was Hawksmoor's work and what was Vanbrugh's. It was never a happy relationship with Vanbrugh as the Duchess was constantly criticising his work and complaining about his extravagance. She was determined, however, to make the palace habitable for her husband, who was by now a sick man. Although the Duchess completed the palace and the bridge according to Vanbrugh's plan, the Triumphal Arch and the Column of Victory were entirely her own ideas.

When the Duke died, he was buried in Westminster Abbey, but after the Duchess died in 1744, he was disinterred and buried with her in the now completed chapel at Blenheim. It was not until twenty years after her death in 1764, that 'Capability' Brown was engaged to landscape the park.

Although the Marlboroughs had no living son to inherit, an Act of Parliament had been passed in 1706 that enabled the title to pass down the female line, which after several generations of Spencers descended down to the late Princess Diana.

During the eighteenth century when the whole country was becoming riddled with rioting and unrest, the government's plan was to encourage each county to raise their

own yeomanry troops to try to control the disturbances. Oxfordshire started with four and, in 1803, the Woodstock Troop was formed by Captain Francis Spencer (Lord Churchill, brother of the 5th Duke of Marlborough). In 1818, Lord Churchill amalgamated his troop with Captain Oldfield Bowles of North Aston's original Wootton Troop. Later in the century, Blenheim Park made an extremely suitable venue for their annual camps until the 9th Duke (d. 1934), who was the last of the Marlboroughs to be associated with the Oxfordshire Yeomanry.

As standards of living gradually improved, so unrest became less frequent. These troops changed names several times before becoming the Queen's Own Oxfordshire Hussars, which was the eventual title granted by Queen Adelaide, wife of William IV, when she visited Oxford in 1835.

In 1874, the palace was to greet another famous Spencer when it became the birthplace of Winston Leonard Spencer Churchill. The Temple of Diana in the grounds will always be known as the place he chose to propose to his bride-to-be, Clementine. After a long and happy marriage and not uneventful lives, he died in 1965, and she followed in 1977. Now they both rest in peace in the tranquil churchyard of the parish church of St Martin, only a few miles away at Bladon. Sir Winston had been a member of the Queen's Own Oxfordshire Hussars from 1900 to around 1920 and was Honorary Colonel from 1953 until his death. It was fitting, therefore, that for his funeral procession a detachment of his regiment had the honour of marching ahead of the coffin as the cortège solemnly paraded through the streets of London.

Rosamund's Well, the site where Henry II allegedly built a bower for his lover Rosamund de Clifford, is found on one side of the lake where a spring fills a large, shallow cistern edged with flagstones, the surplus water draining into the lake. Even before the house and bridge were built, the view from a seat here would have been spectacular. The 10th Duke opened Blenheim to the public in 1950 for families and visitors worldwide as there is always much to see here, from the lavish state rooms to the monuments in the park and the many indoor and outdoor events that are held here annually.

In 1890, the GWR operated trains from a station on the Oxford road, 4 miles from Kidlington. Part of this line ran through land owned by the 8th Duke, who had sanctioned a company for the purpose. The line then ran on towards Oxford but in 1954, it was discontinued. It is not known who devised the name of *Fair Rosamund* for one of the locomotives – in memory perhaps of Henry II's mistress?

A few miles down the road to Oxford are the two small parishes of Begbroke and Yarnton. The road here is dual carriageway, interrupted by three roundabouts. On the first of these, the Royal Sun makes a pleasant break in a journey. Further on, The Turnpike (formerly The Grapes) was where a toll gate once stood when this road was turnpiked from 1719 to 1878. At one corner of the building is a well-worn milestone, one of a number that were erected every mile between Oxford and Worcester, but today only a few remain intact.

Yarnton has always been connected with the Spencer family after Sir Thomas Spencer built a large, Jacobean mansion in the vicinity of the Norman parish church of St Bartholomew in 1611. Yarnton Manor served as a hospital during the Civil War, and the graves of forty Royalist soldiers lie in the churchyard. Sir Thomas added the

Spencer chapel to the church, and three memorials to his family were placed there. The stained glass in the chapel represents branches of the Spencer family and is one of the largest collections of early seventeenth-century stained glass in Oxfordshire. After changing ownership several times, it became the Oxford Centre for Hebrew and Jewish Studies in 1972.

Anyone asleep in their beds in Yarnton on the night of 3 June 1644 would have been rudely awoken as Charles I made a bid to escape capture by the Parliamentarians, who were trying to encircle Oxford to trap him. The King and his troop of 3,000 horses and 2,500 soldiers were giving the Earl of Essex the slip in Eynsham, and Sir William Waller in Islip. Folks must have peered from their windows in fear at the pounding of horses' hooves and muffled voices of soldiers as they careered northwards through the village at full pelt to safety. A few weeks later, on 29 June, the combatants were to meet again at Cropredy.

Peartree, Duke's Cut, Wolvercote to Hythe Bridge Street

Shortly after the Oxford Canal and the River Cherwell part company south of Thrupp, the river goes eastwards on a detour while the canal takes a more structured route to reach Oxford. Just after the bridge, which carries the main road through Kidlington, it passes a row of small cottages where a lady lives in retirement having spent all her working life on the 'cut'.

Rose Skinner was born on her parents' narrowboat and, despite having never learned to read or write, she raised four children with her husband Jack in the late 1940s while carrying coal from Warwickshire to Oxford for Barlows & Co. For many years, they lived and worked on *Kent,* an engine-powered boat in tandem with a butty (or trailer) named *Forget Me Not.* Jack was a nephew of Joe Skinner who, with his wife, also Rose, worked on *Friendship* drawn by a mule called Dolly. She had been purchased from the American Army at the end of the First World War and was to be their constant companion for the next thirty-nine years. They travelled extensively from the Midlands in the last horse-drawn boats on the Oxford Canal.

Having skirted the western fringes of Kidlington, the canal passes the complex of Peartree roundabout, where road, rail and canal all converge. Although work on Oxford's ring road began in the early 1930s, many of the roads around Oxford were redesigned between the 1960s and the 1990s. Previously, part of the A40 and the A34 were linked by a series of roundabouts to form a dual carriageway bypass around the city. During the 1960s, a sweeping interchange roundabout was constructed south of the A4260 from Banbury, using some land owned by Peartree Farm, and which terminates here after passing through Kidlington.

Two main roads lead from Peartree roundabout into Oxford City – Banbury Road and Woodstock Road. Oxford itself has been populated since Anglo-Saxon times. One explanation for its name derives from the many fords that enabled its citizens to cross with their cattle from one side of the river to the other. It was probably a clear choice therefore, that the head of an ox was adopted for Oxford's coat of arms.

Rose Skinner on her son's boat.

The Oxford Canal soon arrives at Duke's Cut, which is a stretch of water extending westwards for 250 yards, linking the canal with Wolvercote Mill Stream, a backwater of the River Thames.

In 1789, Duke's Cut was specifically constructed for George, 4th Duke of Marlborough. He was a large shareholder in the Oxfordshire Canal Company and, wishing to improve his source of income, land within his Blenheim estates was used for the Cut. This enabled Warwickshire coal to be brought by narrowboat down the Oxford Canal and carried through to the River Thames. At the same time, the King's Weir Lock was constructed in order to control the flow of water so that raw materials could be delivered to his paper mill at Wolvercote. The mill, which supplied paper to Oxford University Press, had originally been purchased by the Duke in 1720. From 1782, it was leased to Oxford printer and publisher William Jackson, and by 1811, the mill had been converted to steam. It continued in production until it was finally demolished in 2004.

Wolvercote village is 3 miles north of central Oxford and has its own identity despite being technically part of the city. Ancient grazing rights are still in place for some residents on Wolvercote Green. On the east bank of the canal, tracks lead to Goose Green and rearing geese was once a favoured and profitable activity. Unsurprisingly, a goose is one of the village symbols. Horses and cattle are allowed to graze on these common lands, as well as on Port Meadow a little further south.

At Wolvercote Green, a turning point was constructed for narrowboats, consisting of a V-shaped cut in the canal bank that enabled boats to be manoeuvred into position for

Duke's Cut Lock, taking the canal through to the centre of Oxford.

their return journey north. This was one of the busiest places on the canal and boats queued up, waiting their turn to deliver coal and other goods to the Oxford wharfs. Heyfield Wharf (near Heyfield Road) was a hive of activity with sheds and warehouses, and coal merchants came with their horses and carts to collect deliveries for their customers. There were also blacksmith forges and stables where horses and mules were rested and fed.

Boatpeople might have taken a well-earned rest here while their children played on the common. It is more likely, though, that boatwomen would have been out on the bank catching up with washing clothes and other chores while their menfolk (if they weren't in the local pub!) took the opportunity for a spot of maintenance on their boats. They could be here for several days at a time and children were particularly pleased if a visit occurred at the end of August, as this was when the fair came to Wolvercote Green. A few days later it moved to the rather better known site in St Giles in Oxford.

St Giles' Fair, lasting for two days in September and taking place in this normally busy thoroughfare, was first recorded as a 'parish wake' in 1624. It became a major attraction in the nineteenth century, catering not just for local people but also for hundreds of visitors brought to Oxford by special trains. There was something for everyone with refreshment stalls, side shows, swing-boats at the northern end, a helter-skelter near the war memorial and steam-powered 'gallopers' occupying pride of place near the Martyrs' Memorial, obscuring the façades of some of the fine eighteenth-century houses that line the street.

In 1871, some workmen discovered a complete skeleton of a carnosaur – Eustreptospondylus (a large meat-eating dinosaur) – nearby in an old claypit. It is now housed in the university museum, like the fossils and dinosaur bones found at Enslow, Ardley and Kirtlington.

Port Meadow has always been a popular place for walkers and sporting activities. Apart from horse riding in all seasons, cricket matches are played here in summer and

boats can be sailed on the River Thames. In winter, if conditions are icy and as the whole area is liable to flooding, it makes a perfect ice rink for skaters.

Jericho was Oxford's first planned suburb and is distinguished by its imposing clock tower. The nineteenth-century church of St Barnabas can be clearly seen from the towpath over the backs of Victorian houses in St Barnabas Street. Coal merchants and boat builders have played an important part here ever since the canal opened, and the old forge on the same site must have once been a bustling, cheerful place with horses and merchants coming and going. A short distance from the canal, this popular residential area has plenty of shops and restaurants, and people who prefer a floating home can still use moorings on the canal, despite there no longer being facilities to conduct repairs.

Having passed a number of university boats moored here, the Oxford Canal proceeds through a wooded and secluded area, with houses on its eastern flank whose gardens run down to the water. Nearing the end of its journey, the canal reaches Isis Lock with its attractive iron turnover bridge – its final one marking the junction with the River Thames. After a further quarter mile, it passes Worcester College, almost in the shadow of Castle Mound, the site of a castle built in 1071 shortly after the Norman invasion. There used to be a prison here until the whole area was reconstructed with cafés, shops and a boutique hotel.

Just below an old bridge that carries Hythe Bridge Street eastwards into the city, the Oxford Canal, which started its journey through the Cherwell Valley a little to the north of Banbury some 18 miles distant, comes abruptly to an end. This is not quite the end of the story though. On the southern side of the bridge lies a car park, which was the original terminating point of the canal in 1790. It is hoped that one day this area will be redeveloped to make a fitting tribute to James Brindley's genius and energy to build what has become, over the centuries, an attractive and popular waterway for the many people who make use of its leisure facilities.

Kidlington

As the River Cherwell leaves Thrupp, it parts company with the Oxford Canal and slips off through meadows to the east of Kidlington. Despite its population of approximately 17,000 inhabitants, Kidlington terms itself 'the largest village in England', and its citizens have so far resisted proposals to become a town. It also claims to be an 'apricot village' (similar to Aynho), but with its fruit growing in orchards rather than on cottage walls.

The 1930s, semi-detached houses and bungalows along the main road to Oxford would indicate that this was just a ribbon development for Oxford and that would be all there was of the village. One area is described as a 'Garden City', but a short distance to the east of the main shopping area reveals a much older part. Until the enclosures of 1818, this southern part of the parish consisted of a large area of common land and was known as Kidlington-on-the-Green.

The parish church of St Mary dates from 1220 and has a slender spire known as Our Lady's Needle. The interior contains medieval stained glass windows and some very

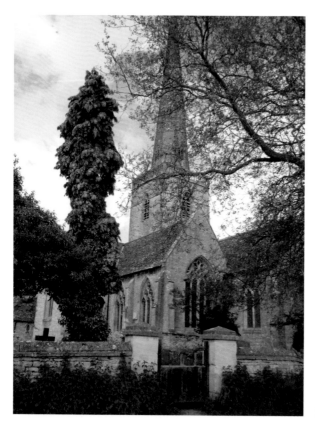

St Mary's church, Kidlington.

early woodwork for both pulpit and rood screen. Alongside the church are some fine, old, greystone houses, one of which is Lady Anne Morton's Almshouse. It was built in 1671 by Sir William Morton, a Royalist officer during the Civil War, in memory of his wife and children whose names are inscribed above the windows. Beyond the church, meadows bordering the river known as St Mary's Fields are a haven for wildlife, and a host of different species can be seen here.

Kidlington is mentioned in Domesday as not only having a certain amount of land but also a mill valued at 10s, and several old mill buildings in Mill Lane have been converted into private homes.

Mill End House is surrounded by a moat fed from the River Cherwell and it is mentioned in a charter of 1220 allowing fishing rights to the then owner. This was passed on some years later to Osney Abbey, who owned it up until the Reformation. It was an obvious place for a fishpond, invaluable as a storage place for live fish and a handy larder for culinary traditions on Fridays and during Lent.

In 1547, Mill End passed to Brasenose College, along with other Osney properties, and has since changed hands several times. In 1984, it was purchased by Sir Richard Branson who extensively improved the property and built a lake that attracts many kinds of wildfowl. He also owns some meadows beyond, to which he has generously allowed public access to these unspoilt habitats.

Another Kidlington mill is mentioned in Domesday as being worth 30s. Osney Abbey built a second mill next to the original one and collected tithes and fees for corn grinding until it passed to the King, who granted it to Christ Church College. Later, this double mill was granted to Exeter College who installed a new wheel and continued to maintain the property until it was converted into a private house in the twentieth century.

The Old Rectory was first mentioned in the eleventh century and, together with its adjacent land, was occupied not only by clergy but also by several tenants unattached to the church, especially after it was acquired by Exeter College. Near the house and one of its chief attractions is a circular dovecote containing nestholes around the inside similar to that at Rousham. Freestanding dovecotes were introduced to this country by the Normans; they were a useful source of fresh meat and the droppings could be used to manure fields.

Hampden Manor in Mill Street dates from around 1250. It was an extensive building from the start and had the advantage of a large fishery. The Hampden family made it their home from 1395 to 1553, until the Mortons moved in. In 1643, Sir William Morton, a lawyer by profession, joined a Royalist Regiment of Horse and received his knighthood from King Charles. He was unfortunate to be taken prisoner by the Parliamentarians and spent some years in the Tower of London. He was eventually able to continue with the law and ended up as a King's Counsel and Judge of the King's Bench. It was he who passed the death sentence on Claude Duval, the notorious highwayman who spent most of his time waylaying ladies in their carriages as they arrived at Steeple Aston crossroads. Later that same year, Kidlington continued to be occupied by Parliamentarians and the following year saw William Waller's troops besiege Woodstock House, which finally capitulated.

Another famous Kidlington resident was Sir John Vanbrugh the architect, who lived at Hampden Manor during the building of Blenheim Palace at Woodstock in the 1700s. As his relations with Sarah, Duchess of Marlborough, were no doubt under some strain, he must have been glad for an escape from the palace. It is believed that he also designed the square tower at the manor to serve as a water closet that drained into a stream that now runs underground along Mill Street, before emptying into the River Cherwell. Presumably for residents' sakes, this practice has long since been discontinued.

In 1840, Thomas Beecham (of Beecham's Pills) is understood to have lived with his uncle at Kidlington and, for a time, was employed as a jobbing gardener. His medicinal recipe was believed to have come from a particular herb growing beside a shepherd's cottage and that his first customer was the local doctor, who presumably lived to tell the tale. More fame was to come to the family as Mr Beecham's grandson, Sir Thomas Beecham, Bart., C. H. (1879–1961), was an impresario and conductor, best known for his association with the London Philharmonic and Royal Philharmonic orchestras.

Prior to 1964, when it was closed down, GWR planned Kidlington station as part of Oxford & Rugby Railway, opening in 1852. On dismantling the station in the 1980s, it was discovered that Isambard Brunel had designed the actual station building. Apart from its historic buildings, Kidlington has a modern shopping centre

and the headquarters of the county Fire & Rescue Service, St John Ambulance and the Thames Valley Police. On the northern outskirts, conveniently between Heathrow and Birmingham, is Oxford Airport, which was renamed London Oxford Airport in 2009.

Gosford Bridge and Weston-on-the-Green to Islip

By the end of 1643, King Charles was well established with his court in Oxford, as long as his forces held most of the towns round about. He was able to relax for a while with his nephews Prince Rupert and Prince Maurice, by playing 'real' tennis with his sons on a newly built court and, on other occasions, hunting at Woodstock. In April 1644, the Parliamentarians under the Earl of Essex and Sir William Waller, in an effort to besiege Oxford, captured Bletchingdon House and set up their headquarters there. In early May, Waller made an attempt to cross the Isis and failed and the Skirmish of Gosford Bridge followed. It started with Essex being twice thwarted by the King's General, Sir Jacob Astley, from crossing the Cherwell at Gosford on both 30 and 31 May, with much bloodshed and men badly wounded. Essex also attempted to cross the river at Enslow Bridge and Tackley but was again repulsed by Astley's forces and forced to retreat.

One fascinating and perhaps apocryphal story of the Civil War relates to when Prince Rupert was on his way back to Oxford and stopped for the night in a monastery

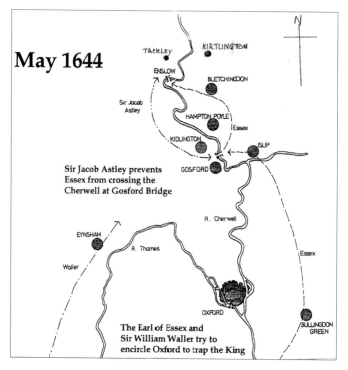

Battle movements during the Skirmish of Gosford Bridge. (Adapted from map drawn by Bilham Woods)

Fierce fighting took place here at Gosford Bridge.

at Weston-on-the-Green. Apparently, General Fairfax, Cromwell's commander, also decided to put up there for the night and was shown into the same room. Prince Rupert speedily leapt into a fireplace and hid there unnoticed, waiting until the General was fast asleep before making his escape disguised as a dairymaid. Safely back in Oxford and after much toing and froing, both sides met up again at the end of June at Cropredy. After a series of skirmishes and the Royalists having captured the Parliamentary guns, King Charles and his troops retreated back again to Oxford.

Weston Manor, a fine Tudor mansion that takes its name from the original monastery, was for many years in private ownership until 1919, when the last heir was killed during the final days of the war. The whole estate had to be sold and has been run as country hotel and restaurant since then. A little north of the village is Weston airfield, built in the First World War and still used for military parachute training and as a civilian gliding club.

On 23 April 1645, Charles I was still based in Oxford and awaiting supplies. Cromwell meanwhile was advancing on Islip from the south, as he understood a Royalist garrison was stationed there. On the way, he met a fisherman called Beckley who offered to ferry his troops along the River Cherwell, thereby bypassing Islip Bridge and outflanking the King's soldiers. After this cunning manoeuvre, the bridge was captured and fighting continued through the village streets, causing much damage. Cromwell, who had been watching the whole battle from the top of the church tower, was so pleased with Beckley that he granted him fishing rights in perpetuity. (The fisheries that had been in existence since medieval times continued to be valuable until the late nineteenth century, and were central to providing an industry for making osier cages for trapping eels).

Just over a year later, in the early hours of 27 April 1646, a secretive, crouched figure who appeared to be a servant with a short haircut, no facial hair and with

More fighting
took place at
Islip Bridge.

two companions, rode swiftly over Magdalen Bridge and straight up the hill through
Headington en route for London. In May, the King surrendered to the Scots.

In 1995, the Sealed Knot Society came to the village to perform one of their
well-known re-enactments of the 1645 Battle of Islip Bridge.

Islip's most famous son perhaps was Edward the Confessor, who was born here
in around 1005. Dr William Buckland (the legendary discoverer of the dinosaur
Megalosaurus) makes yet another appearance as he was Islip's rector for eleven years.
He resided at the rectory mainly during summer and autumn, combining this position
with his post as Dean of Westminster. He died in 1856 and is buried in the churchyard.

Woodeaton and Water Eaton to Oxford and Christ Church Meadows

Having skirted Kidlington, the River Cherwell crosses under a road that links up
with the A34 to Islip. After being joined by the River Ray coming from Islip, they
turn southwards between the two tiny hamlets of Woodeaton and Water Eaton.
Woodeaton is blessed with a thirteenth-century church and some cottages grouped
around a triangular village green. On its western side, the parish slopes gently down
to flat water meadows. In medieval times, villagers were allowed to build weirs in
order to trap fish here, as long as they did not cause flooding in fields further away. An
eighteenth-century manor house is chiefly noted for the work done by Sir John
Soane, who built an Ionic porch, decorated the main rooms and added a two-storey
service wing in 1791. This design was much the same as the one commissioned by
the Cartwrights at Aynhoe Park. On the northern edge of the village, the remains of
a Romano-Celtic temple have been found and some bronze artifacts from the site are
housed in Oxford's Ashmolean Museum.

A manor house at Water Eaton was purchased by Richard, 1st Baron Lovelace, in 1624. During his time there, it was recorded that he was in arrears by £12 for ship money. After his death ten years later, he was succeeded by his son John who, as a staunch supporter of Charles I, gave away some of his property for the Royalist cause. John married Anne, daughter of Lord Cleveland, one of the King's Generals who defeated the Roundheads at Cropredy Bridge. There is a tale that on 1 September 1644, twenty-one-year-old Lady Lovelace was forced out of Water Eaton Manor by some disgruntled Roundhead troopers and bundled into a carriage. They then drove at speed to Middleton Stoney where she was abandoned and made to return home on foot. Was this revenge for their defeat by her father's troops, perhaps? She evidently suffered no lasting harm and continued to live on as a dowager at the manor long after her husband had died.

The River Cherwell continues to flow south again through farmlands until it touches the eastern edge of Summertown. Passing under Marston Ferry Road, it receives the first hint that it is about to enter the centre of a famous city. Oxford University is the oldest university in Britain, having its origins in informal groups of masters and students who gathered in Oxford in the twelfth century. Each of the thirty-three colleges, dating from the twelfth to the twentieth centuries, has an individual charm and interest, and all are frequently open to be visited by the public.

One well-loved landmark is Sheldonian Theatre, built for the university in the seventeenth century after a design by Christopher Wren. No plays are performed here, but it is a scene of many university ceremonies and concerts. No one can quite decide to whom the sculpted heads on the railings outside belong – they could be Greek philosophers or Roman Emperors or perhaps the Twelve Apostles. The originals have long since deteriorated and they have been replaced at least twice.

Some of the other prestigious university institutions include the Bodleian Library, founded in 1595 by Sir Thomas Bodley (1545–1613) as the university's library and

The river passing the Victoria Arms at Marston.

national depository. Also of note in the Old Schools quadrangle is the Tower of the Five Orders, related to the five styles of classical columns – Tuscan, Doric, Ionic, Corinthian and Composite. They stand one upon another, and high up on a throne is the figure of King James I. Opposite him, standing on a plinth, the fine bronze statue heroically clad in a suit of armour is William Herbert, 3rd Earl of Pembroke, who was University Chancellor from 1617 to 1630.

The University Press was founded in 1585, and its demands gave rise to the number of paper mills that were built along riversides. The Ashmolean Museum was founded by Elias Ashmole (1617–92), who donated the core of his collection to the university in 1675. A purpose-built museum opened eight years later. In 2008, it was closed for over a year for a complete renovation, allowing space for special exhibitions and many more artefacts to be put permanently on display.

In modern times, recognition must be given to William Morris (1877–1963) who built his first car here in 1913. Both his vehicles and factories at Cowley – albeit fewer of them in the twenty-first century than the twentieth – are famous worldwide. He was later created 1st Viscount Nuffield and, being a great philanthropist, founded the Nuffield Foundation and Nuffield College.

Oxford's history goes back to the earliest arrivals of monks and nuns, who brought the new Christian religion and set up their monasteries and nunneries in what was then the countryside. At Godstow on the banks of the Isis (or Thames), a few greystone walls remain of the abbey that was once a nunnery. St Frideswide, who was seeking to escape from an unwanted marriage, is traditionally considered to be the first of these. A monastery was built in AD 727 in a marshy area (from which the later walled town of Oxford developed) and her shrine rests in Christ Church Cathedral, believed to be the site of the original building. Small though the town then was, its roads were laid out on a grid plan. By the ninth century, the crossroads at Carfax marked Cornmarket and St Aldate's on its north–south axis, and Queen Street and The High its east–west axis. During the Middle Ages, much of the land was owned by the church and the wealthiest was the Augustinian abbey at Osney. After the Dissolution, their lands were sold off cheaply to nobles and merchants throughout the county, as well as to some of the colleges.

Later on, kings would come to visit the city and during the Civil War, King Charles, his wife and his court were based here. Until he made his dramatic escape from Oxford disguised as a servant, King Charles resided at Christ Church, stabling his horses in the famous quadrangle. At Wolvercote he had an agreement with land tenants there to provide hay for his stables and one of the two mills there was used by armourers to grind sword blades for soldiers. Meanwhile, in the city, Queen Henrietta and her ladies occupied rooms in Merton College. During this time, university life must have been sorely interrupted.

The first college that the river passes is Wolfson College (one of the newest) with its contemporary buildings that were completed in the 1970s. It owns grounds on both sides of the river, which are connected by a rainbow bridge. Two ancient meadows opposite the college are believed to have never been ploughed, fertilised or changed in any way since medieval times and in springtime, put on a dazzling display of wild flowers.

Back on the other side and a little further downstream is the Cherwell Boathouse, which has an array of punts with flat bottoms for gliding over shallow water. These are available for hire to customers who can steer their chosen craft with varying skills on the now navigable river. The punter stands raised at one end (with his several passengers reclining on cushions in the main part of the vessel) and proceeds by allowing the pole to slip through his hands vertically onto the riverbed. This manoeuvre enables the punt to be pushed along until the punter raises the pole for the next downward thrust. Timing is critical as it is all too easy for the punter to be left clinging to the pole while the craft moves swiftly away downstream.

From here, the river is imperceptibly static with hardly a ripple. It passes the Dragon School playing fields, followed by the elegant brick buildings of Lady Margaret Hall, founded in 1878 and previously one of the all-women colleges.

The river next passes by University Parks, an area of well-loved footpaths for walkers and sporting activities, particularly cricket in summer months. Oxford University Cricket Club (OUCC) is home to men's cricket and has a long and distinguished history dating back to the eighteenth century. The two university sides, the Blues and the Authentics, play their home games in the parks, which have been the home of OUCC since 1881, when cricket was first officially played there. The parks, incidentally, were so named because during the Civil War, Royalist artillery was

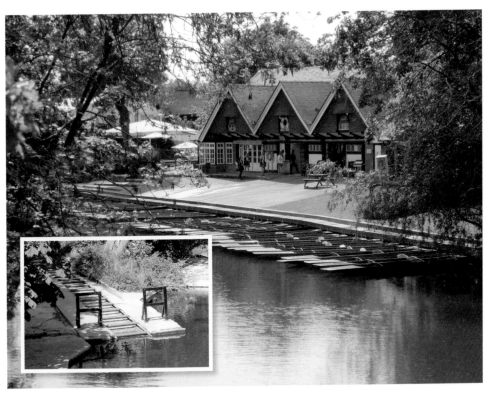

Cherwell Boathouse and punt rollers at 'Mesopotamia' (*inset*).

A skilled punter.

'parked' there. King Charles evidently also found them a convenient area for walking his dogs.

Located near the parks is the Oxford University Museum, where the original bones of the Megalosaurus and Cetiosaurus can be viewed within its cavernous, cathedral-sized gallery and plaster casts of dinosaur footprints are embedded in a grassed-over area outside.

Part of Victorian folklore of Oxford University is Parson's Pleasure, which was in a secluded area on the river bordering another side of the parks, specifically for male nude bathers. Nearby, Dame's Delight was a similar location for female nude bathers. Many tales abound concerning these facilities, which finally were rendered defunct by the 1960s.

From here, the river splits into two or three streams with a series of islands. One of these is named Mesopotamia, where there are some conveniently placed punt rollers at the northern end next to a weir.

And now, the River Cherwell approaches the very heart of the city where ghosts of past dons, tutors and students must surely lurk among historic streets and alleyways connected with university life. Apparitions that are legendary among students often take a form of shadowy figures of monks.

This is not surprising, considering the number of holy orders that originated here during the thirteenth century. The list makes for colourful reading and includes Cistercians, Dominicans, Franciscans, Carmelites, Augustinians and Trinitarians, not to mention Whitefriars, Blackfriars and Greyfriars. By the end of the sixteenth century, with Henry VIII's sacking of the monasteries, all these hooded characters quietly faded from the scene.

Magdalen Bridge.

One fairly obvious place to harbour a ghost is Deadman's Walk. It is situated between Rose Lane and Christ Church Meadow's entrance from Merton Street, and Colonel Windebank, the Royalist soldier, is said to haunt this area. His crime was to surrender Bletchingdon House to Cromwell without a fight, resulting in him being tried, found guilty of treason and shot. Apparently, in St John's College, Charles I has been observed playing bowls with Archbishop Laud, both using their own severed heads. A headless man has been seen riding an ancient bicycle over Magdalen Bridge and, on another occasion, a 'black man' has been reported falling off the bridge. There are many further tales of this nature, but fortunately, there are plenty of other attractions to divert not only local people but also the many thousands of tourists who come to 'the city of dreaming spires' every year.

Some interesting curiosities to be seen in Oxford are high above eye level, and the visitor (mindful of the traffic) should constantly gaze upwards to appreciate all the statues and gargoyles that adorn the tops of older buildings. Not many shops these days retain signs indicating their trade, but there are a couple of examples in The High near to the university church of St Mary. A bishop's mitre is visible over the entrance to the Mitre Hotel and, across the road, a large white dog holding a watch in its mouth sits above a silversmith's shop. Payne & Son, established in the city since 1888, is still owned by the same family specialising in fine antique and modern silver.

Magdalen College (pronounced 'maudlin'), beside the bridge of the same name over the river (one of the oldest and some say most beautiful of the colleges), was founded in 1458. It is believed that there was once a ford here in Anglo-Saxon times, near to where the bridge now stands, to connect the royal estate of Headington, which then lay on both sides. Some of the notable persons who came to study at Magdalen include

Cardinal Wolsey, Edward Gibbon and Oscar Wilde. Its tower is a famous Oxford landmark and ever since the time of Henry VII, the college choir have sung madrigals standing on its top every May Morning at dawn. They sing, among other things, a salute to the poet Milton:

> Hail, bounteous May, that dost inspire
> Mirth and youth, and warm desire

Parties are held the previous evening and by early dawn on 1 May, crowds flock along to Magdalen Bridge from which hardy souls traditionally jump fully clothed into the River Cherwell below. With recurrent low water levels, this has become too dangerous and various schemes have been tried out to curb this event. Oxford is not the only place in the county that celebrates May Day, as nearly all the villages along the Cherwell Valley have their own versions with dancing and garlands to welcome the coming of spring. In the nineteenth century, it was school children who were encouraged to take on the tradition, with both boys and girls performing as May kings and queens and dancing round a maypole.

On the other side of Magdalen Bridge, between the river and Christ Church Meadow, is Oxford Botanic Garden, the oldest botanical garden in England. It was originally laid out on the site of an old Jewish cemetery and, in the seventeenth century, it was well known as a physic garden, growing herbs for medicinal purposes. It also became

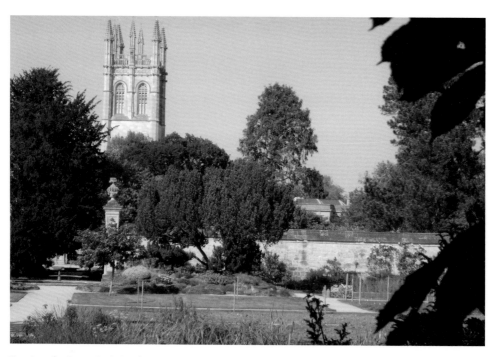

Passing the Botanical Gardens.

Slowing gliding down the Isis.

Christ Church meadows.

an important centre for propagating species from the New World. In 1669, the first Professor of Botany was appointed and one of its chief benefactors was Sir Joseph Banks who founded the Royal Gardens at Kew.

Across the meadows – a great expanse of trees and grass where cows can graze – lies Christ Church. It is one of the largest colleges and also houses the Cathedral church for the Diocese of Oxford. 'Tom Tower' is famous for its peals of bells and, due to its height, can be glimpsed from the meadows as well as different places in the city. Cast in 1680 and weighing over 6 tons, 'Great Tom' is still tolled 101 times at 9.05 p.m. every night to signal that it is time to close the college gates.

In 1851, Charles Dodgson was studying mathematics at Christ Church when he met the children of the then Dean. The stories that he made up for them resulted in his books, *Alice's Adventures in Wonderland* and *Alice Through the Looking Glass*, which he wrote under the name of Lewis Carroll. On the other side of the road from the college gates is Alice's Tea Shop, selling souvenirs as well as refreshments. More recently, fans of Inspector Morse and Harry Potter will recognise some of the college areas where filming took place.

And by now perhaps, the fully mature river can scent its final destination. Through clusters of trees it can glimpse the River Thames in disguise, as for a short distance through the centre of Oxford it has always been known as the Isis. Having travelled through villages, fields and forests for close on 40 miles since its inception on Halidon Hill, it has grown in stature along the way. With a slight quickening of pace and barely taking a backward glance at 'Tom Tower' across the meadows, its journey's end is within sight and the River Cherwell gracefully sinks with ease and recognition into the Isis. Very soon the River Thames regains its more familiar name and, in harmony and gathering volume, both rivers surge together towards London to finally merge with a mighty ocean beyond.

The River Cherwell joins the Isis coming from the right.